GALACTIC
GEOGRAPHIC
ANNUAL 3003

Historic First Contact

A famous encounter is revisited for our annual issue.

Chosen for the cover of our Annual from all the images in the *Galactic Geographic* archives, "First Contact" typifies the spirit of our organization: Humans and extraterrestrial intelligences united in the pursuit of scientific knowledge.

The image, recorded in the year 2820, documents a young Federation's chance encounter with an alien race. In the picture three crew members from the sublight cruiser *Magellan* meet three alien crewmen.

Writes Commander R.J. Powers, captain of the *Magellan*, "We detected something that at first looked like an asteroid. But we knew that regions of star formation seldom have rocky components. Of course once we tracked it at fractional light speed we knew it was a ship.

"We sent out a hailing message on the SL wave and the photonics. Even tried radio, but they didn't see us. It took a burn of our G-pulse for them to notice us."

Powers recalls a cat and mouse game that lasted for several days.

"We were thousands of kilometers apart most of the time and finally broke the ice by slowly moving toward them. I suppose it was mutual curiosity that brought our ships together.

"We decided an EVA was the best way to meet. We knew the risks, but it was worth it. In retrospect it was ominous that both parties brought along instruments on the EVA. Any of them could have been weapons. But somehow neither of us sensed a threat.

"In the end we knew little more about the aliens than when the incident began. But one thing was clear to all of us. There IS intelligent life out there."

Today the Federation of Worlds includes five sentient spacefaring races among its members. Strangely, none of them is the mystery race that met the *Magellan* almost two hundred years ago and became mankind's long awaited "first contact."

Karl Kofoed • *GALACTIC GEOGRAPHIC*

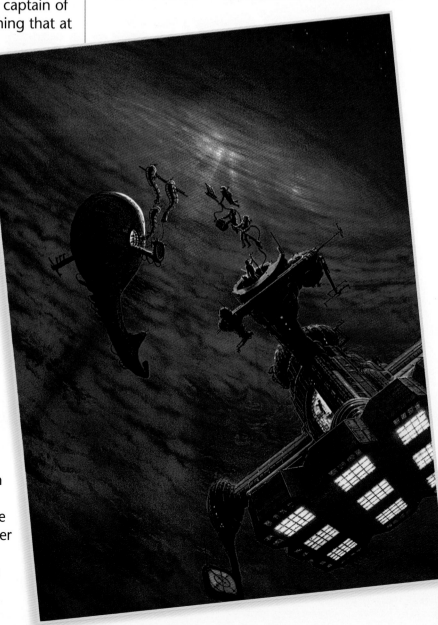

✦ GALACTIC GEOGRAPHIC

Dedicated to the Endless Exploration of the Cosmos

Karl Kofoed – Annual Creation & Production
Paul Barnett – Editor
Jan Pagh-Kofoed – Inter-species Editor

MARS BUREAU – Isidium Colony

L.A. Thompson – Transmission Specialist
L. Prato – Terraformer Division – Isidis
R. Walters – Technical Support – Image Specialist
T. Kissinger – Xeno-Paleontological Bureau
G.B. Frost – Federation Protocol Specialist
M. Howarth – Xeno-Technologies, Harvest Institute
J.S. Baltadonis – Chief Terraformer Liaison

PLANIS BUREAU – Planis Colony

C.J. Parker – Image Specialists
J.B. Mayhew – WO Technical Liaison
D. White – Technical Liaison
Q.K. Thompson – DataTrans – Planis-Tachyon

TSAILEROL BUREAU – Tsailerol Colony

R.J. Miller – Xeno-Geology Specialist
J. Hagen – Tsai-Tech – Xeno-Paleontology
H. Clement – DataTrans Services – Tsai-Tachyon
ghonh Nge'b **meHS** • Wa'yoD ta'ahre, H'ach
en Ibya' **Qatlhs**. • Qut poms tIch loS II, 'ejyo'S
vagh Doq'Slon jma **vatlh** • Dujs bo, Wa'

NORON BUREAU – Noron Colony

J.G. Douglas – Editor and Technical Liaison
J.A.T. Wysor – Federation Starship Tech-Liaison
E.R. Bush – Editor and Aqua-Colony Liaison
S. & A. Lougheed – Liaison to RV Colony
P.G. Fricano – Noron Data Translator
W. M. Ridenour – DataTrans Imaging
S. Sucharitkul – Music Liaison
M.S. Prato – Inter-Species Relations
G.S. Dozois – DataTrans – Noron-Tachyon

Special Thanks

K. Eastman, D. Jurofsky, T. White, S. Kelly, A. Porter, D. Hoy
J.H. Frank, D.W.K., K.W.L., P.F., A.W.L., D.E.K.

Features

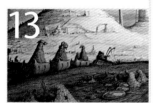
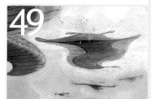
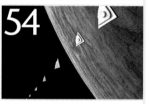
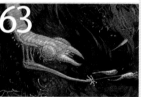
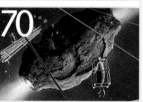

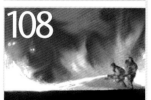

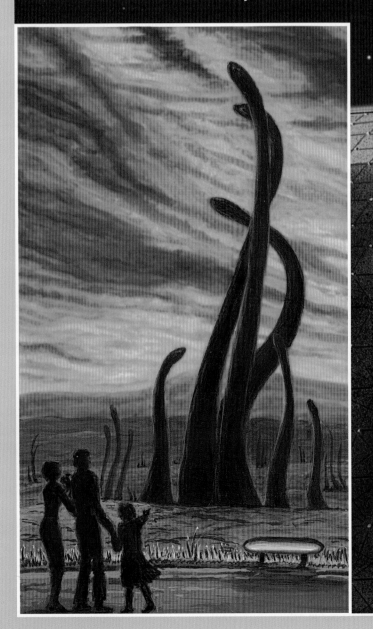

gical Gardens

The only Xenobiological Zoo in the Universe

TerraTours Skycars provide all types of excursion vehicles for Myhr visitors. These and other recreational gear may be rented at specified centers at our park.

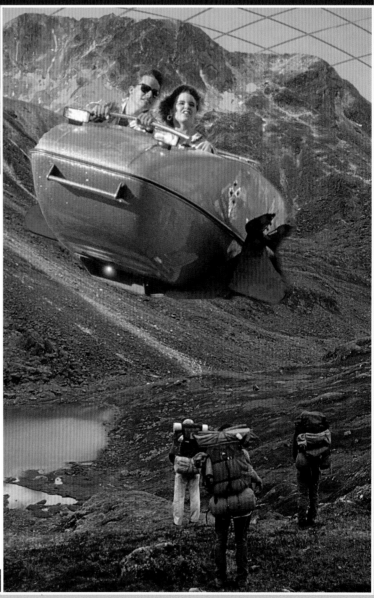

Most people think visiting a major attraction like the Myhr Gardens is a budget-stretching experience. Not so at Myhr.

Vacations, conventions, or family outings, there is a Myhr experience to fit your budget. We are a non-profit institution with Interworld status dedicated to promoting the preservation of life throughout the galaxy. At Myhr, all visitors are welcome!

Visitors are welcome in all parts of the Myhr Center, even for trips to the Tsailerol farming colony in the Exo-environs section inside Myhr Mountain.

You can enjoy traditional recreational activities while taking advantage of the special features Myhr offers.

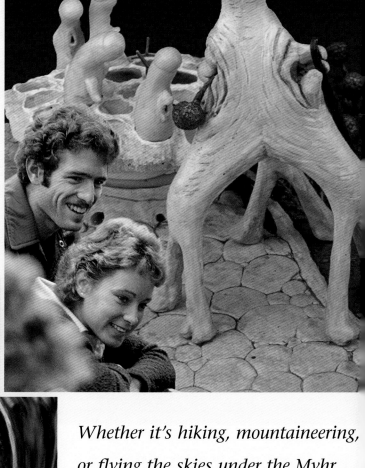

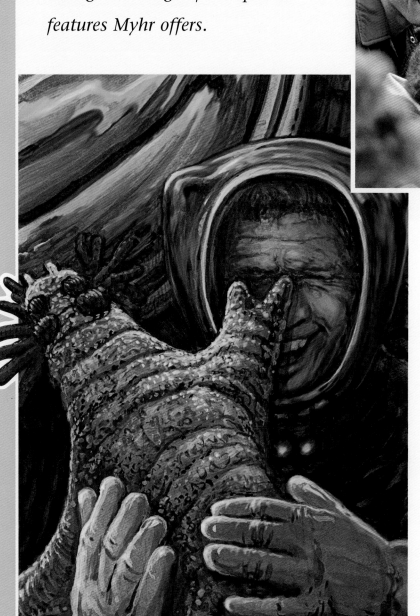

Whether it's hiking, mountaineering, or flying the skies under the Myhr dome, everyone is guaranteed to find fun and excitement.

ABOVE: Visitors to the Tsailerol Terracolony compound are usually greeted warmly by the colonist farmers and their children.

LEFT: Interspecies relations are tested in the many off-world environs maintained inside Myhr Mountain. Here, a researcher wrestles with a feisty critter rescued from a planet doomed by a wandering black hole.

OPPOSITE: Myhr Skyport – only minutes by Tubeway from the Myhr Center

We Invite you to...

...visit the habitats of colonists representing other worlds.

...see life transported to Earth from doomed planets.

...enjoy the many museums and exhibitions at Myhr City – a metropolis dedicated to the study of Xenobiology, Technology and Cosmology.

Take the kids!

A great place to learn about the Universe around us.

Holovert recreations, like this Rootsnake rookery on Talus 4, allow tourists to safely tour toxic or inhospitable environments.

Children ponder planets colliding in one of the many interactive exhibits at Myhr.

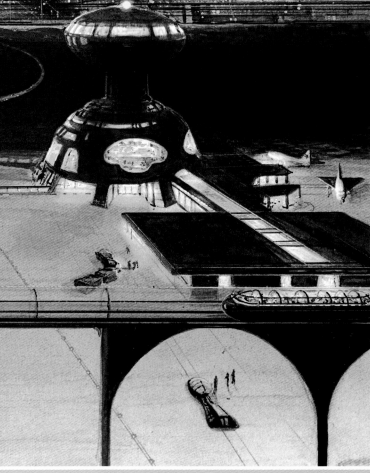

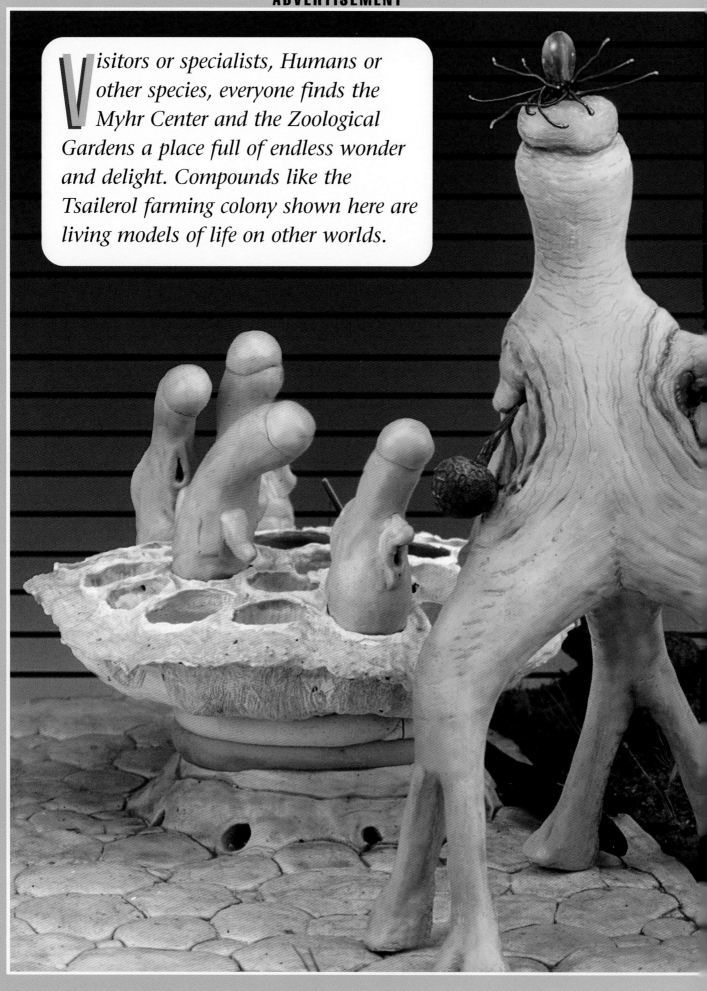

Visitors or specialists, Humans or other species, everyone finds the Myhr Center and the Zoological Gardens a place full of endless wonder and delight. Compounds like the Tsailerol farming colony shown here are living models of life on other worlds.

The Myhr Zoological Gardens

*T*he Myhr Center welcomes you to an adventure paradise under a dome. More than an amusement park, it is a world of many worlds dedicated to the preservation of universal life. Since its creation in 2960, the Myhr Center has served as a home for life facing extinction on Earth or elsewhere in the galaxy.

Group tours arranged for all languages and species.

DOME PERIMETER

TERRESTRIAL ENVIRONS

MYHR CITY

PARKLANDS

MOUNTAIN

SHUTTLE ROUTES

EXTRATERRESTRIAL ENVIRONMENTS
See Key Below

North Americ

Central America

Middle America

Amazor

How to Get There: The Myhr Center is accessible from all major skyports and tubeway centers on Earth. Punch **TW*MYHR** at any Inter-World Tubeway hub and you will be guided safely to the destination of your choice. The Myhr Center is located at Trans-Siber, Earth, and has accommodations for guests requiring special gravities and environments.

The Myhr Zoological Gardens and Center for Xenological Studies

Area of dome – 28 sq. km. Dome Diameter - 6km Population 12000-15000

Key to Environments

| Methane | Sulphur | Toxic | Silicon | Toxic Liquid | Water 2 | Terran |

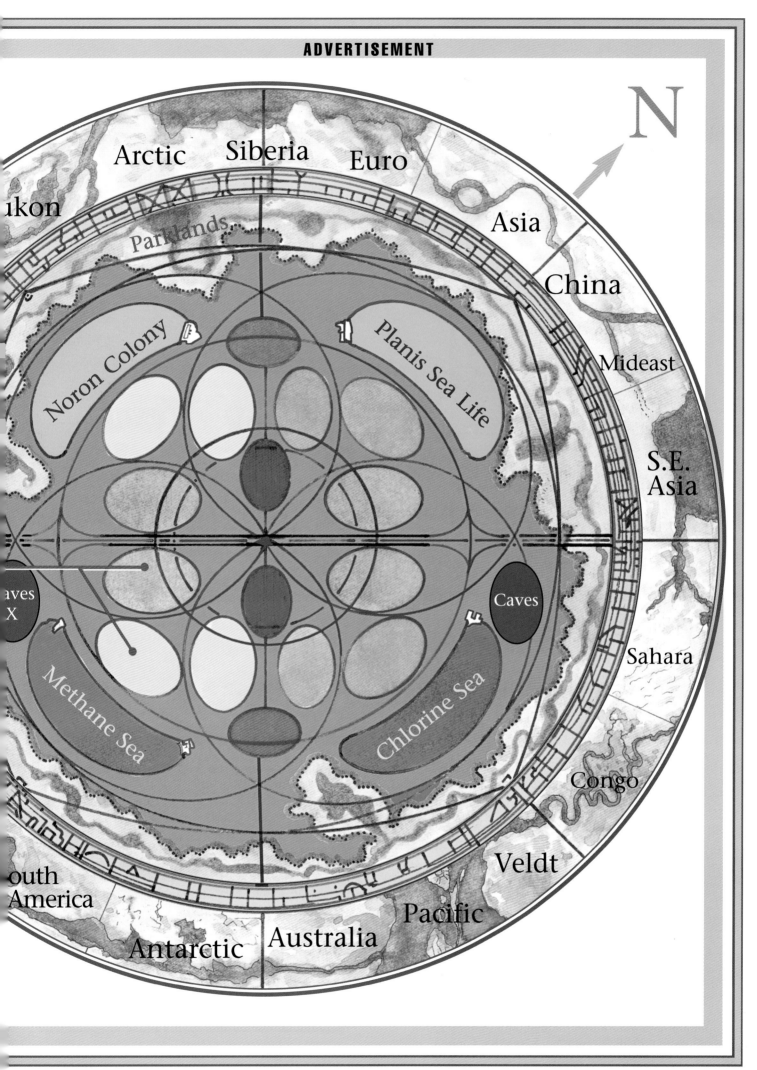

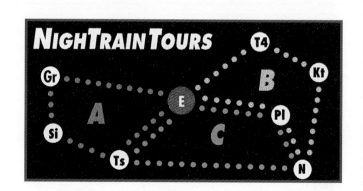

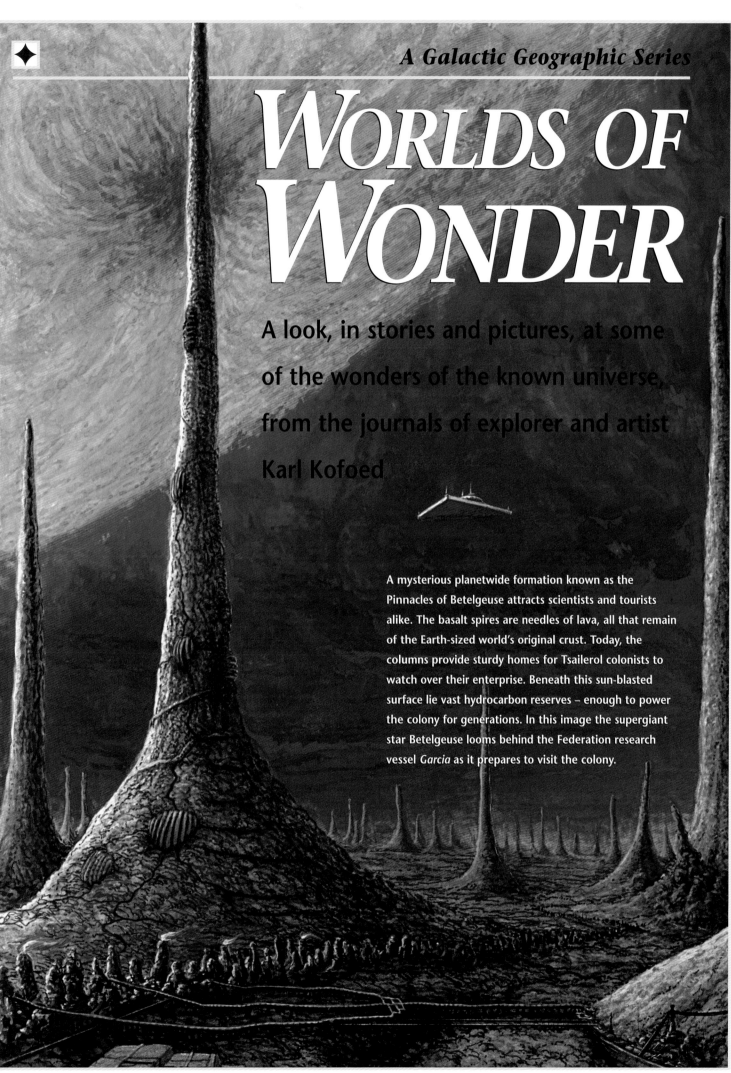

WORLDS OF WONDER

A look, in stories and pictures, at some of the wonders of the known universe, from the journals of explorer and artist Karl Kofoed

A mysterious planetwide formation known as the Pinnacles of Betelgeuse attracts scientists and tourists alike. The basalt spires are needles of lava, all that remain of the Earth-sized world's original crust. Today, the columns provide sturdy homes for Tsailerol colonists to watch over their enterprise. Beneath this sun-blasted surface lie vast hydrocarbon reserves – enough to power the colony for generations. In this image the supergiant star Betelgeuse looms behind the Federation research vessel *Garcia* as it prepares to visit the colony.

Millennium Starship

Like a giant mountain served on a platter, Serius's Explorer Colony Six speeds toward the Galactic hub at .6 lightspeed. Here it encounters a meteor shower, but three fields of magnetic flux protect the community of 200,000 citizens from any meteoritic mass smaller than a half kilometer. The colony is a facsimile of their home planet, its mountain and valleys providing varying climates nourished by the light of a solar projection.

In the foreground a shuttle ejects a mechanic in a stasis module to effect repairs on an orbiting satellite. We learned that such craft are made from materials mined within the mountain. Underneath the platform a massive machine commands trajectory, interspace communications, and sensors, freeing the populace to concentrate on research, exploration, and survival. Periodically they send faster-than-light tachyon transmissions to their home world, an estimated 115 light years away. During those times they may be vulnerable to impacts from meteors.

Visiting Federation members estimate that 40% of the colony's power is devoted to tachyon production.

The Earth-based ships *Goddard* and *Houston* have visited the Serian vessel on diplomatic missions. Their research suggests that the Serian starship was constructed to provide its citizens freedom from the rigors of starship travel. A happier populace, it was apparently reasoned, would assure continuing loyalty to the home world.

Now, entering a fourth generation aboard the ship, there is evidence of a shift in that loyalty. The drain to their power systems of communicating to an ever more distant home world has increased over the years to the point where such transmissions have become of necessity less frequent. And there is also evidence that the normally insular Serians are now more open to contact with other races, such as those in the Federation. This is evidenced by their willingness to share data about themselves.

But, in spite of that openness, Federation policy demands that its members keep a handle on their curiosity. First contact with an alien race is stressful for both parties, so our policy reflects the old axiom that exploration requires patience. *(continued)*

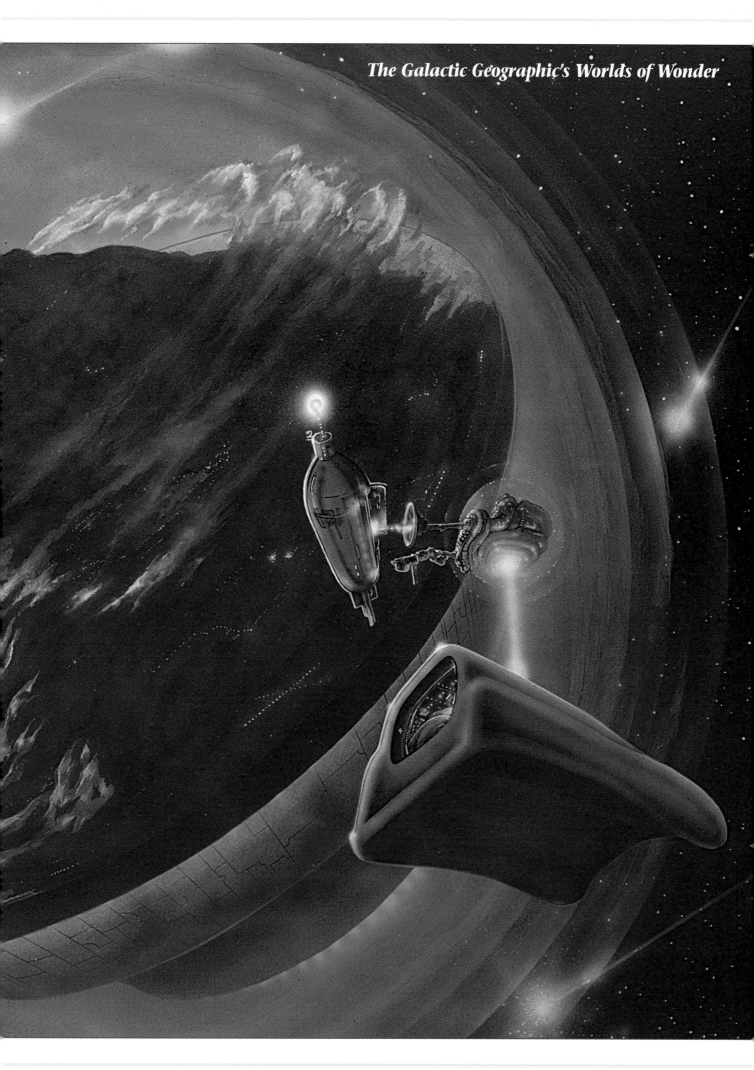

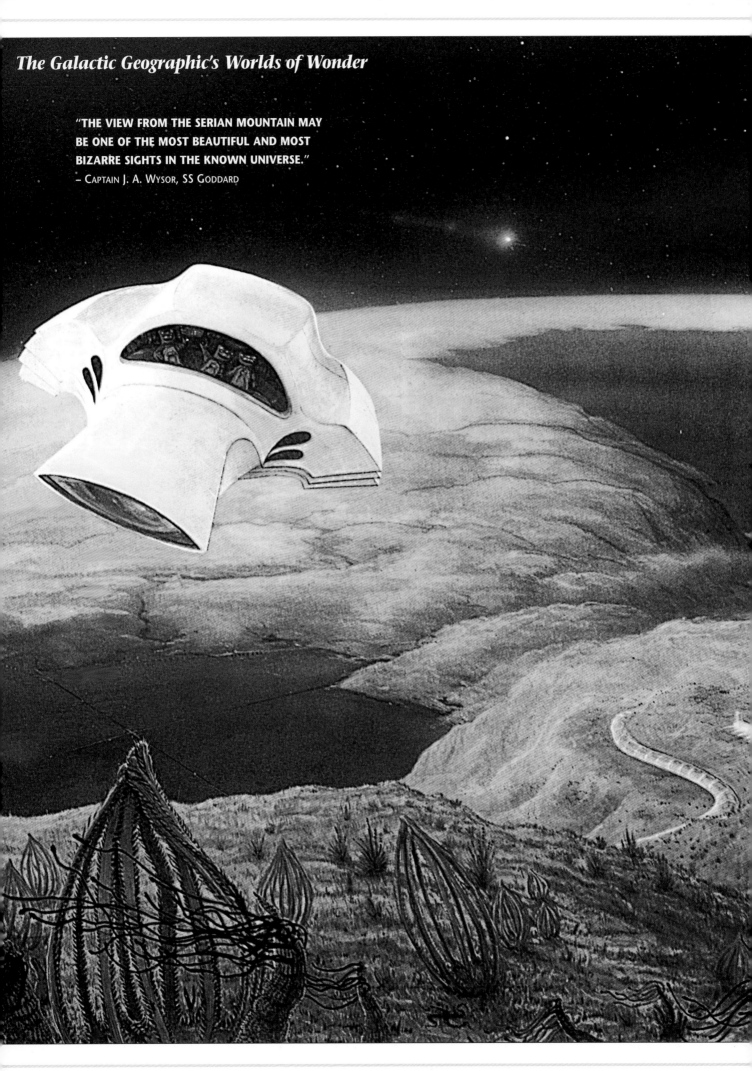

The Galactic Geographic's Worlds of Wonder

"THE VIEW FROM THE SERIAN MOUNTAIN MAY
BE ONE OF THE MOST BEAUTIFUL AND MOST
BIZARRE SIGHTS IN THE KNOWN UNIVERSE."
– CAPTAIN J. A. WYSOR, SS GODDARD

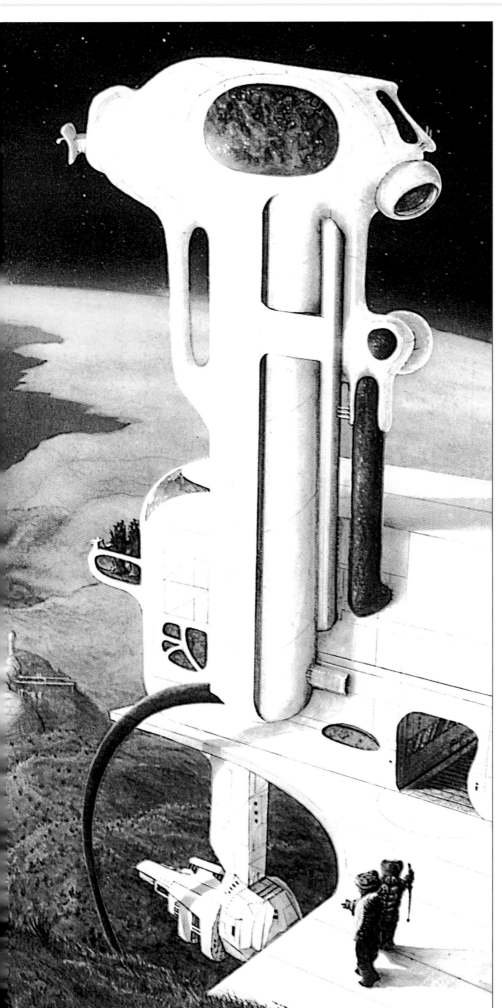

"The view from atop the Serian mountain is oddly claustrophobic," remarks Karl Kofoed, the *Geographic* team member who recorded this image and the one on the preceding page. "I've stood on asteroids this size, but they're nothing like this world on a plate."

First impressions can be deceiving. One glance at the teddy-bear-like Serians implies something huggable to most Humans, but colonial explorers are trained not to touch. In times such as these the Colonial Imperative guides our actions. The policy has opened worlds and trade for mankind, and has brought our group of galactic citizens to the top of this mountain.

Here, a waving group of Serians in an airship buzzes by our group. Below us, beyond the crops blowing in the breeze, our gaze is drawn to a lake. Beneath its placid surface can be seen the superstructure upon which the whole colony was built. Gravity is provided by a continuous acceleration of .6G. Occasionally it is necessary to make course corrections or slowdowns when their speed passes .8c. At such times the Serians drain the lake to a chamber below the mountain. Then the population braces for a few days of discomfort. Our group of Humans, Noron, and Tsailerol spent seven weeks touring the colony and was invited to inspect nearly all of the surface, but was not permitted below ground. We never actually saw the machine that generates the magnetic field which drives the ship, and it still remains a mystery how the Serians generate artificial sunlight. We did notice that the projection follows a solar path with a 17° axial tilt, telling us something, at least, about their home world.

Tests showed that Serian life is carbon-based with atmospheric oxygen levels twice that of Earth. Though the air was breathable, Federation members followed protocol and wore sealed environmental suits during the entire visit.

The Serians have graciously allowed five *Galactic Geographic* members to stay aboard their starship for an indefinite period, so we expect further interesting reports in future issues of the magazine.

HARVEST ON INSADOR

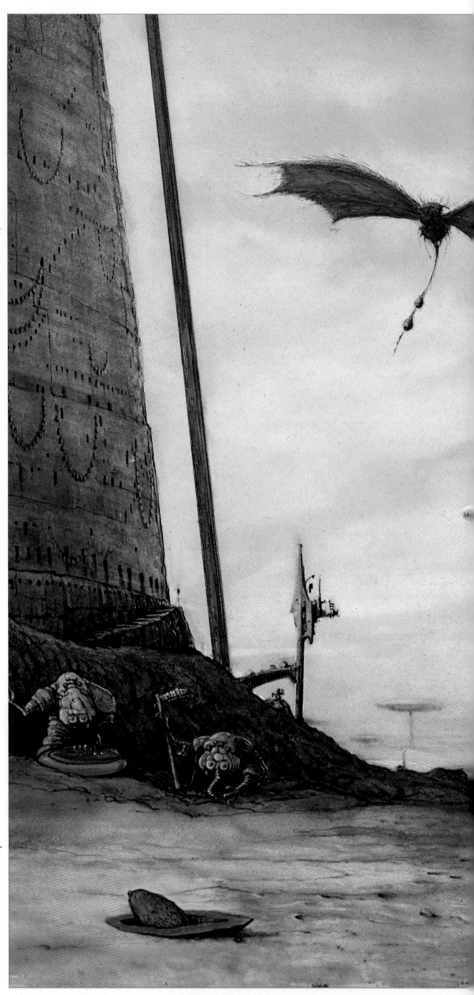

One of the "Thousand Wonders of the Galaxy," the giant rock platforms of Insador seem to march over the horizon, while, on the rolling plains below, its citizens, called Troadis, harvest green santooth plants *(lower right),* whose nourishing oil is a staple in food and trade for the inhabitants of this dry world.

Despite the potential wealth and technology that could accrue from trading in this resource, the insect-like Troadis steadfastly employ the primitive harvesting methods of their ancestors, such as the worm-powered transport, seen with carts of santooth at right, and the spiny-winged pack-bird, carrying oil to trade depots.

Trading for food, tools and machinery, Troadis have developed a fondness for machines featuring blinking lights and moving buttons. This has motivated traders to build pseudo-machines specifically to trade with them.

Here, two blue Troadis amuse themselves with just such a toy. Above and behind them oil pots hang from hive openings in the ancient stone walls.

In the distance *(at right)* santooth husks burn brightly with excess oil at the base of a monolith, a sign of a successful season.

The Troadis are the only known civilization to occupy the monoliths, each one housing a community of over 20,000 whose lives are devoted to santooth production.

The origin of these stone structures remains a mystery, but Federation scientists suspect that the monoliths may have been built to humidify the planet, a function they still perform. Water from underground rises by osmosis up the columns to saturate the cave-riddled platforms above. There, dry air flows through the caves, gathering moisture and dampening the atmosphere. The effect is minimal, just enough to keep the crops growing. It seldom rains, so the plants of Insador can survive only near the monoliths, which girdle the planet at mid latitudes. What lost civilization built these stone platforms may forever remain an unexplained wonder.

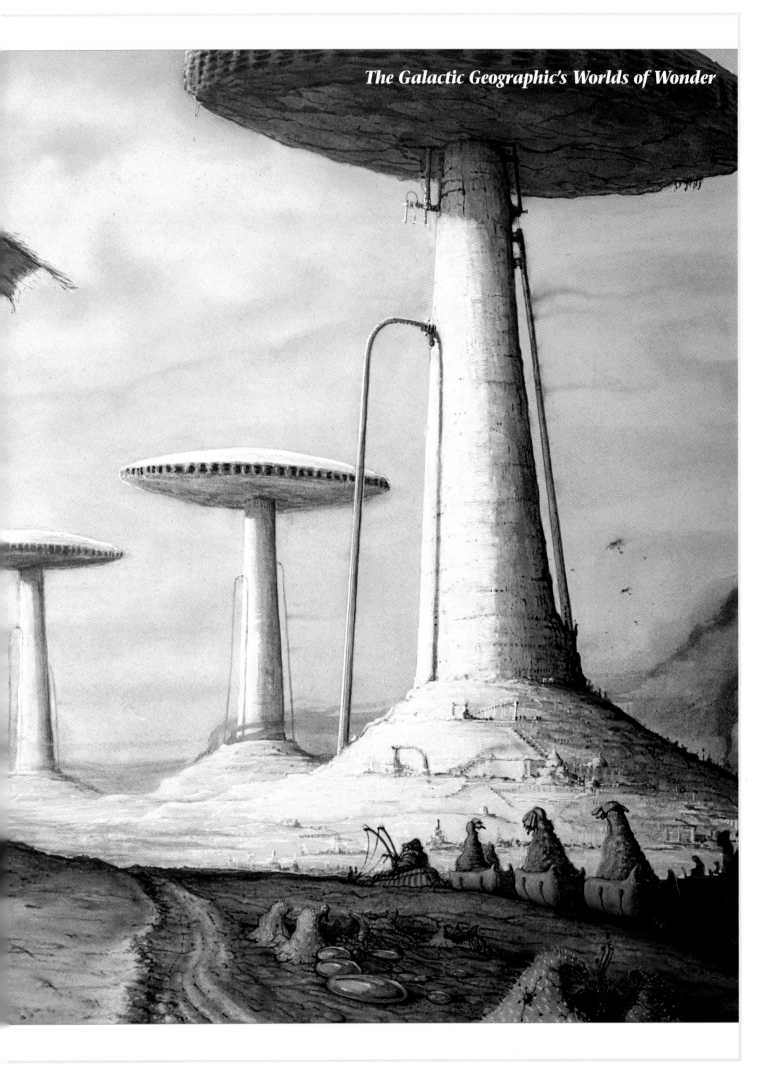

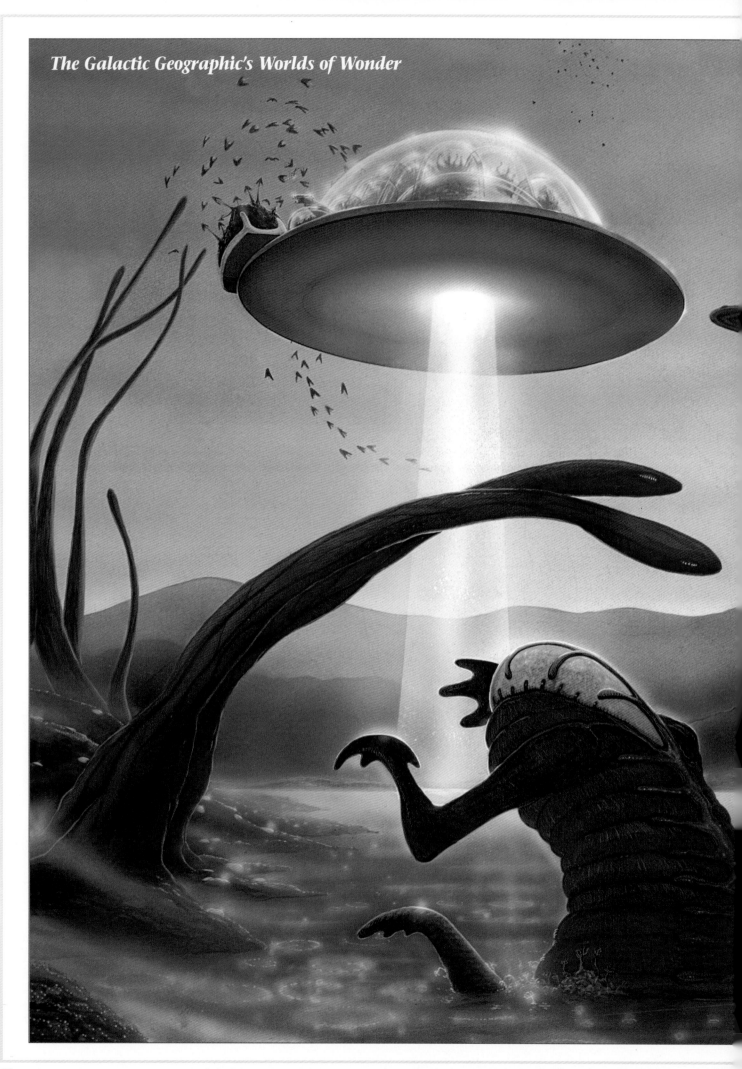

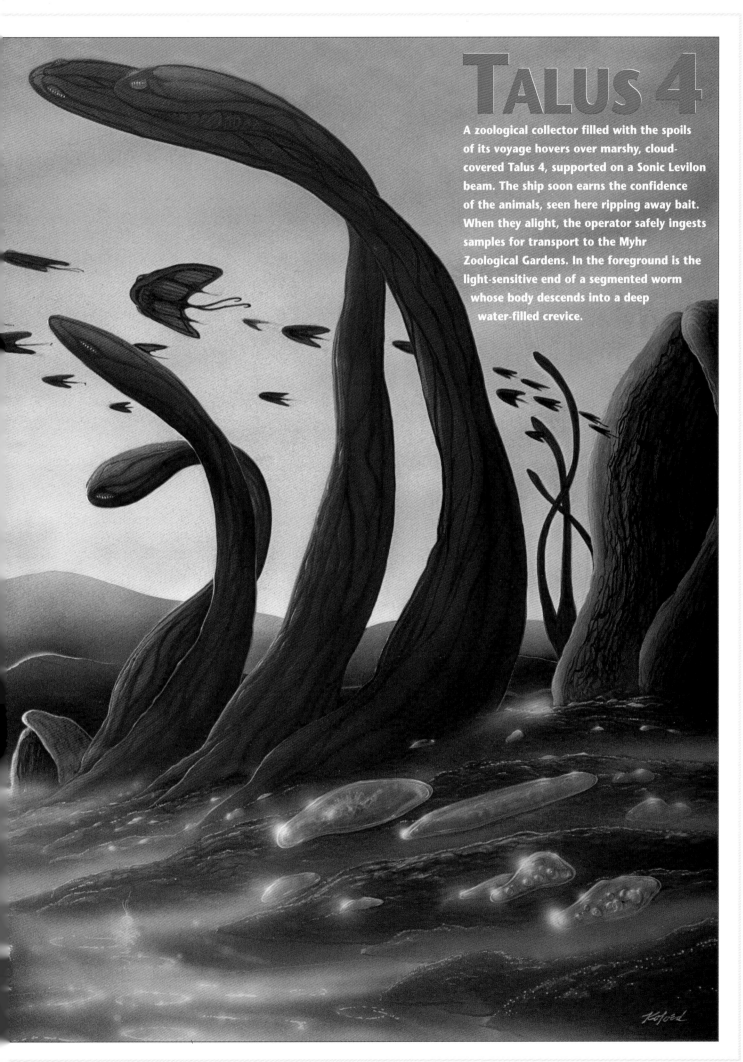

TALUS 4

A zoological collector filled with the spoils of its voyage hovers over marshy, cloud-covered Talus 4, supported on a Sonic Levilon beam. The ship soon earns the confidence of the animals, seen here ripping away bait. When they alight, the operator safely ingests samples for transport to the Myhr Zoological Gardens. In the foreground is the light-sensitive end of a segmented worm whose body descends into a deep water-filled crevice.

LIFE ON A VIRGIN COMET

The barren, icy world of the comet is the only known home of the therm-trap, a meter-sized living greenhouse that houses a community of organisms living in ecological balance. They are sustained by the comet's main ingredient, water.

Called a virgin comet because it has never passed close to a star, Comet Stubbs is a permanent traveler in the vast dark regions of interstellar space. This comet is named for its discoverer, Dr. Harold Stubbs, who has studied over 200,000 comets using detection gear of his own design.

Interest in therm-traps is not based solely on scientific curiosity. They produce a waste product that stays fluid in space, an ideal lubricant for machines used in supercool environments.

Science has learned that the therm-trap is a delicate system of animals centered on a creature supporting a lenslike organ. It keeps this moving "eye" focused on the brightest light in the sky, absorbing all the energy it can. It has a tenuous grasp on life, slipping easily into long periods of dormancy triggered by loss of light – a natural defense. But it is sensitive, too. Should too much lubricant be removed from its base, it will lose heat and perish. Thus, the therm-traps remain a mystery to frustrated biologists, who study them only from safe distances.

Sadly, with its waste oil so popular on the black market, and no substitute thus far invented, the survival of this unique species remains in question.

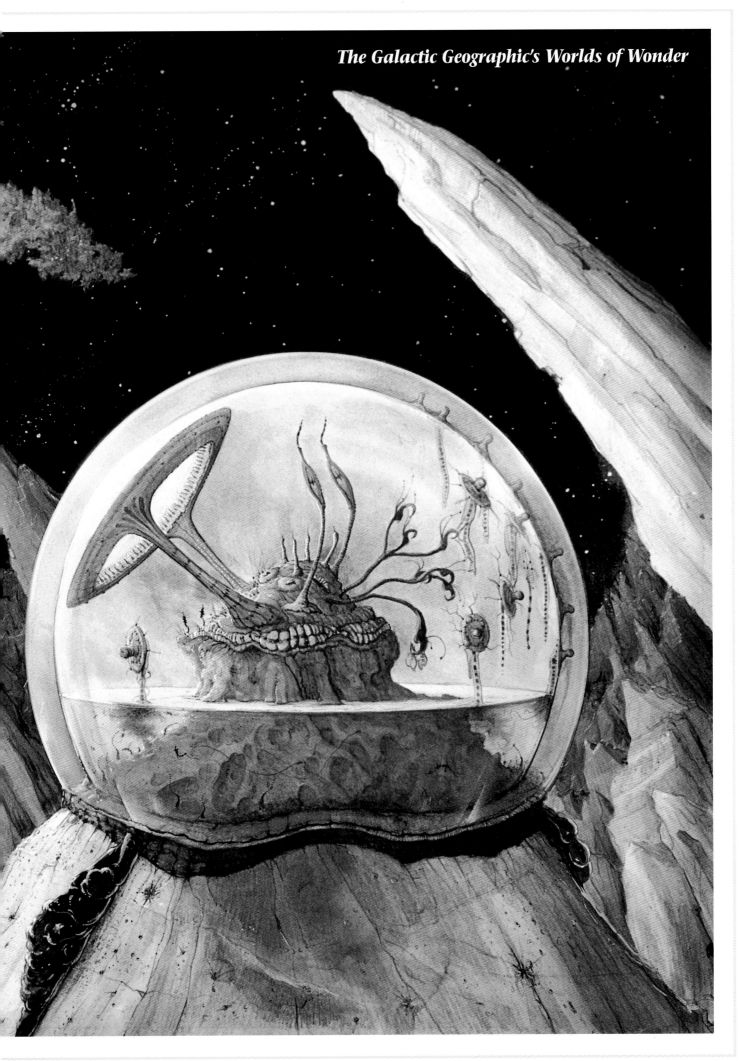

The Galactic Geographic's Worlds of Wonder

TOWER
OF JUI-QUILAR

Visitors to the barren planet of jui-Quilar are rare. This world is little more than a relic of its former glory, having once had an estimated population of 70 million. Now a hostile, mountainous world with only one small sea, jui-Quilar used to be a verdant planet with an ocean of waterways between the mountains. These fjord-like canals served as a food source and trade route for the populace, who lived in small villages at the water's edge. But 1300 years ago the seaway dried up, leaving the population cut off from each other. So dependent were they on the sea that the populace dwindled to a mere 50,000 living on the shore of their one remaining sea. They responded to their plight by building a spiral tower, the remains of which are pictured here.

Xenoarchaeological surveys have found that the tower was constructed to restore the planet by stimulating the atmosphere to cause rain. How the builders hoped the machine would accomplish this is unknown. Experts on jui-Quilar suspect that it was a fool's venture, like the pyramids of Earth. The planet is renowned for its violent electrical storms, and it is known to have been one such storm that destroyed the tower and with it much of the future of jui-Quilar.

On a festive date over a thousand years ago the main body of the tribes gathered at the newly constructed bronze tower to witness the machine begin the rain that would restore their seas. A storm started at noon, and massive bolts of lightning hit the tower and the water tanks at its base, causing an explosion of such force that all the tribal leaders and their heirs were killed, as were most of the witnesses to the event – some by shock waves that reverberated between massive rock walls, and some by tons of stone that fell into the small valley where all the celebrants had gathered. One quote from the jui-stone found near the structure seems to describe the event:

"Tremors of [bronze] were cast up [mountain] at [one sea] by 20,000 of the Kamak and Trith and Dissn [tribes] for the Fire that torrent to be [sustained]. By Bjui did storm. The fire cast to her [link] and [sons of sons of sons] did fall." Translation: Dr. J. O'Boyle - PHL Center - Earth

In all, perhaps 12,000 perished, leaving those remaining leaderless and without hope. The relic today stands as a monument to a dead civilization, attracting visitors only as a side-stop on the way to some less depressing locale.

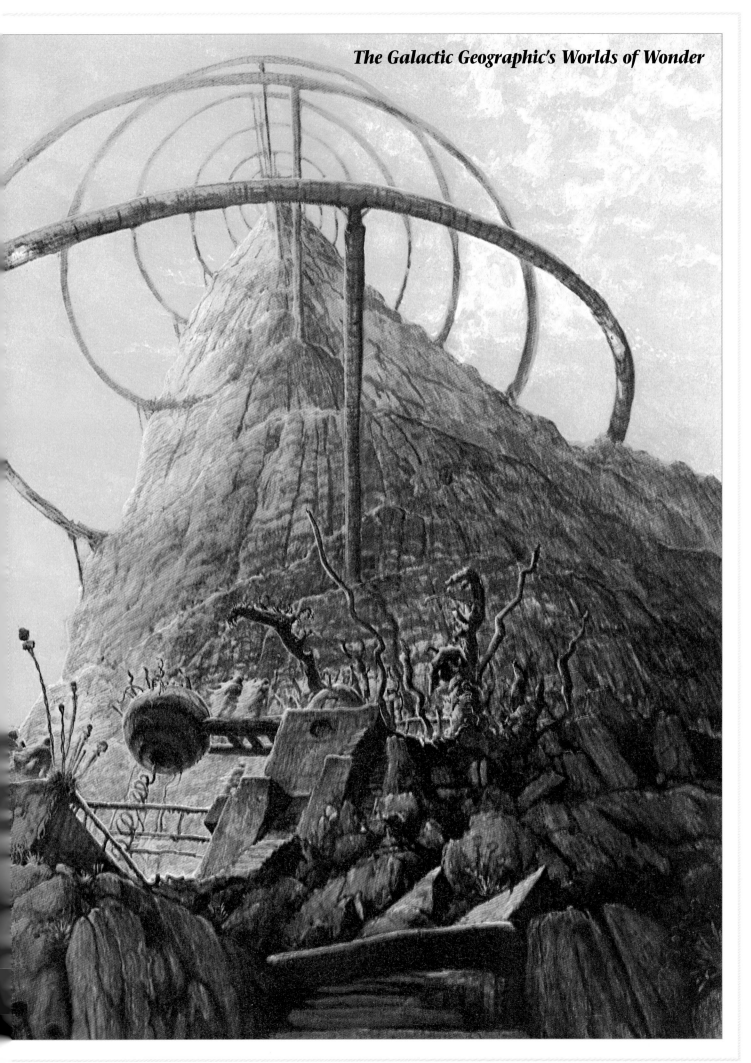

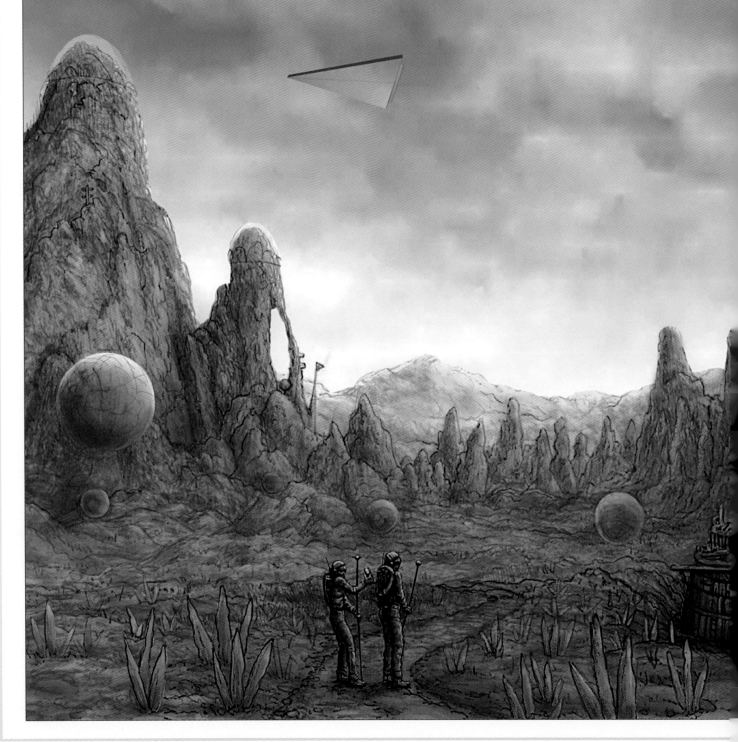

Not every colony is a success. This Tsailerol outpost once supported a half-million colonists – until a fungus took over.

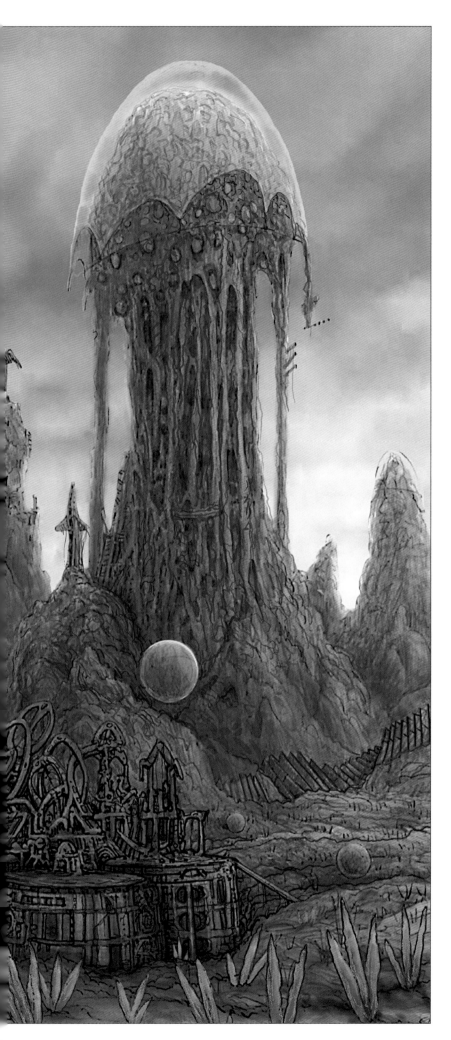

KIER'KI'MOS –TOXIS

Colonized over seventy years ago by the Tsailerol, the world they named Kier'ki'mos now bears the suffix Toxis – meaning poisonous. But it is called "Shroomworld" by Human *Geographic* researchers.

Matt Howarth, director of the Human mission that first visited the colony, recalls, "When we arrived we were shocked to find the planet completely abandoned. It was nothing like the one described in Tsailerol records. Our survey concluded the entire biosphere had been contaminated.

"The contagion – a simple fungus-like organism thought to have migrated to the planet in the Tsai colonists' air or water supply – spread globally, replacing indigenous life with a new ecology of its own design. And nearly all of it is toxic to the native life."

Howarth also notes that it must have happened with unprecedented speed. "We've not seen anything like this before. No doubt cosmic radiation and elements in the new environment caused mutations of the non-native spores. Sadly, the planet's lifeforms had no defenses with which to fight the invader."

Seen in this painting by *Galactic Geographic* artist Karl Kofoed are abandoned Tsai water converters and gestation tanks, a communications center, and even a Tsai shuttle nearly obscured in the undergrowth, the presence of which is a frightening testimony to the speed of the infestation and subsequent evacuation. The tent-shrouded peaks are presumed to be relics of efforts by the Tsai to arrest the spread of the initial contamination, which may have occurred in areas receiving the most light.

Several variations of invader fungi are represented in the image, including floating gas-filled sacs, rock-hard spikes, and spongy fungal mats. Here, two EV-suited investigators are traveling a road once used to harvest food that fed the colony of over half a million Tsailerol. Now those studying this plundered world can only walk amidst the ruin and wonder if something like this could happen again. "This is a colonist's worst fear realized. But it's the only known case of global contamination," concedes Howarth. "We all hope it'll be the last. The Tsai have learned a hard lesson, one that none of us will ever forget."

(continued)

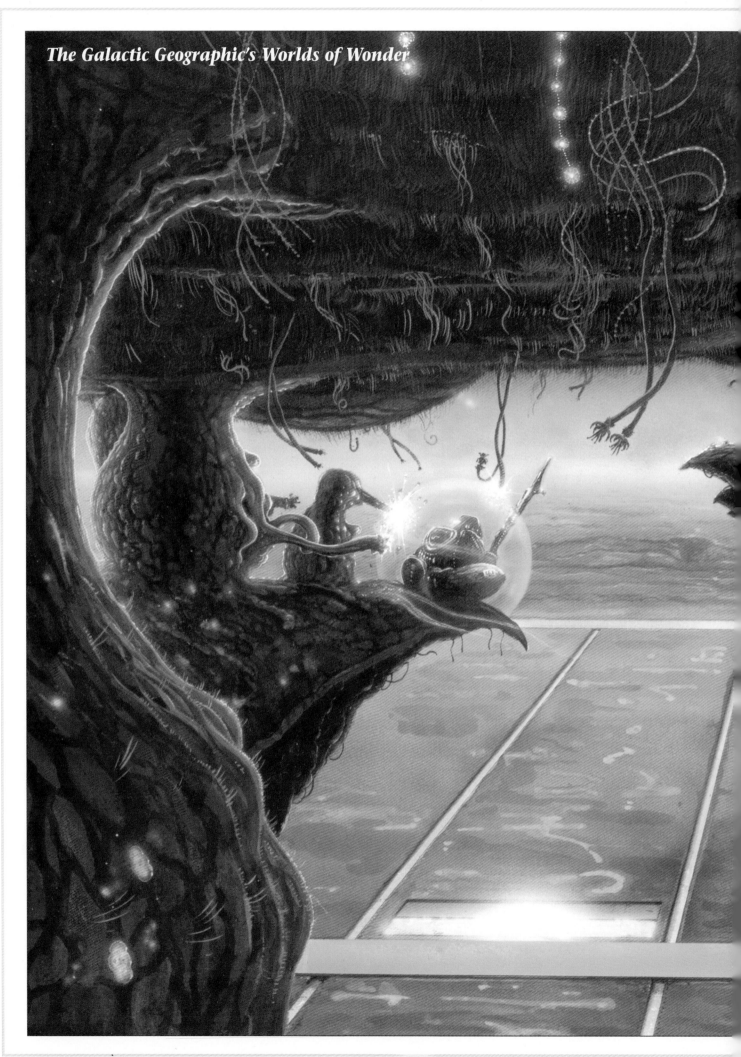

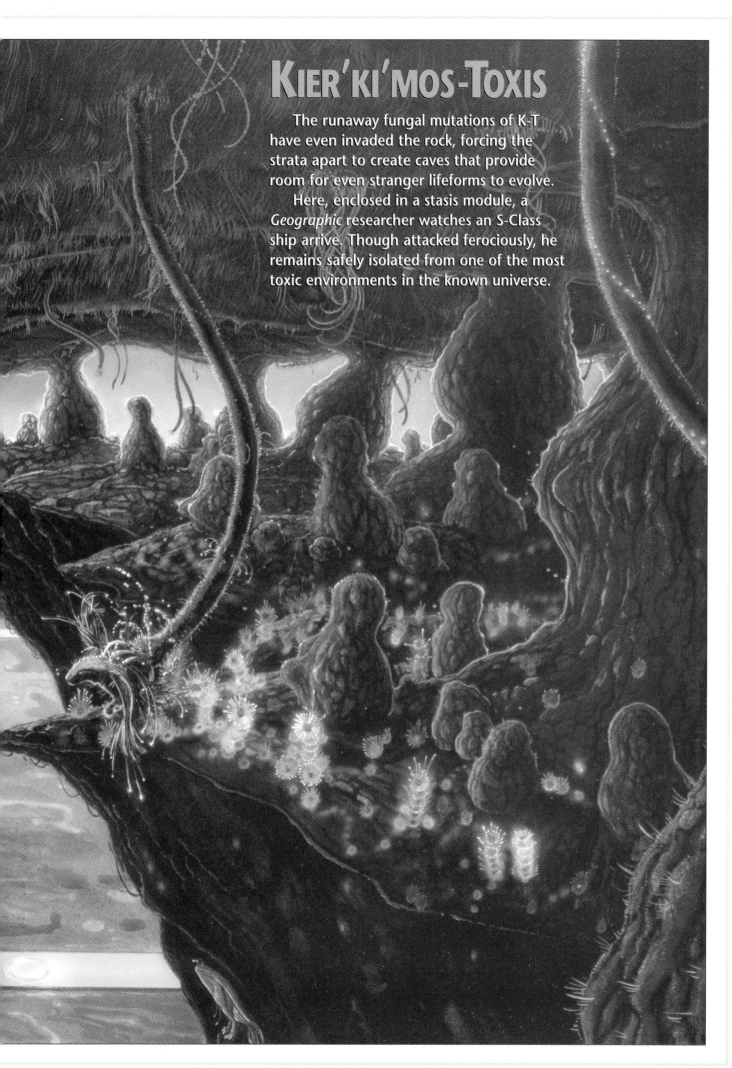

KIER'KI'MOS-TOXIS

The runaway fungal mutations of K-T have even invaded the rock, forcing the strata apart to create caves that provide room for even stranger lifeforms to evolve.

Here, enclosed in a stasis module, a *Geographic* researcher watches an S-Class ship arrive. Though attacked ferociously, he remains safely isolated from one of the most toxic environments in the known universe.

GREEN
PLANET OF ETERNAL DAY

"It's called Green," says the planet's discoverer, L. A. Thompson of the starship *Houston*, "because it looks like an emerald floating in space. It seems Earth-like and peaceful, but its beauty is matched by the hostility of its lifeforms."

Here, a xenobiologist witnesses that hostility. Once like Earth, this world is billions of years older. Now the planet is locked in resonance with its star, rotating only once a year. One side bathes in permanent sunlight while the other freezes in eternal darkness.

The planet's ecosystems have evolved to keep pace with such adversities, however. On the sunlit side, a canopy of vegetation has grown to a height of twenty miles, covering the land. This blanket of life siphons excess heat to the night side of the planet.

But the cost of living here is war on a grand scale, particularly at the shorelines where creatures of land fight for space and survival against those living in the sea. So crowded is this side of the planet that even the air is filled with floating algal mats.

Green is an evolutionist's dream. But how to study it? The Federation's answer was a Magnetic Stasis Module (MSM). While it did provide protection, the frightening view shown here left a lasting impression on its pilot, Charles Parker. "We wanted to study the shoreline but there was no place to set down," recalls Parker. "Then I spotted a clear space that looked perfect. But when I set down I got the surprise of my life. Something exploded from the ground and attacked. Without the MSM I'd have lasted two seconds."

Shaken but otherwise unharmed, Parker now leads a permanent team studying this fascinating hothouse world. But today all the study is done safely – from orbit.

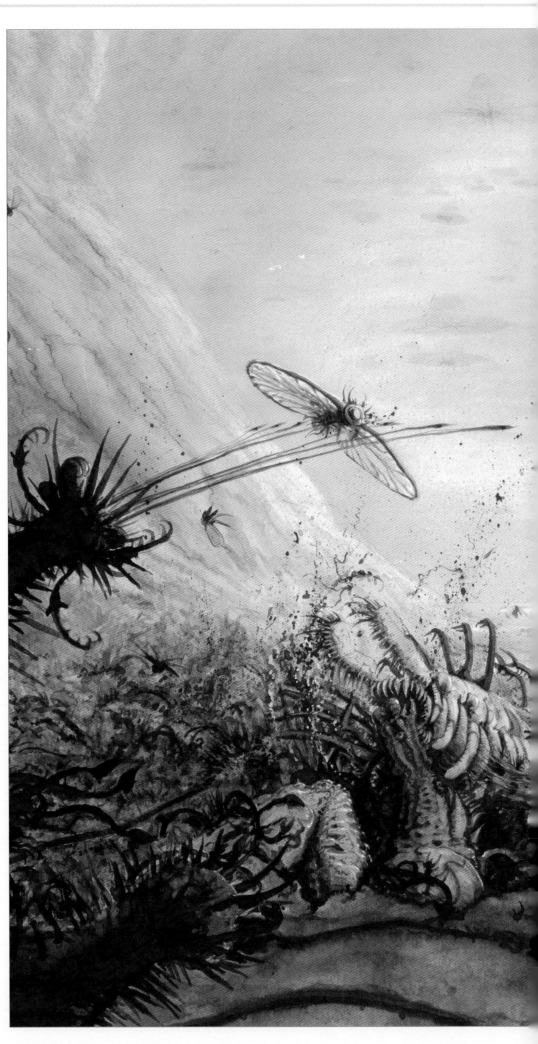

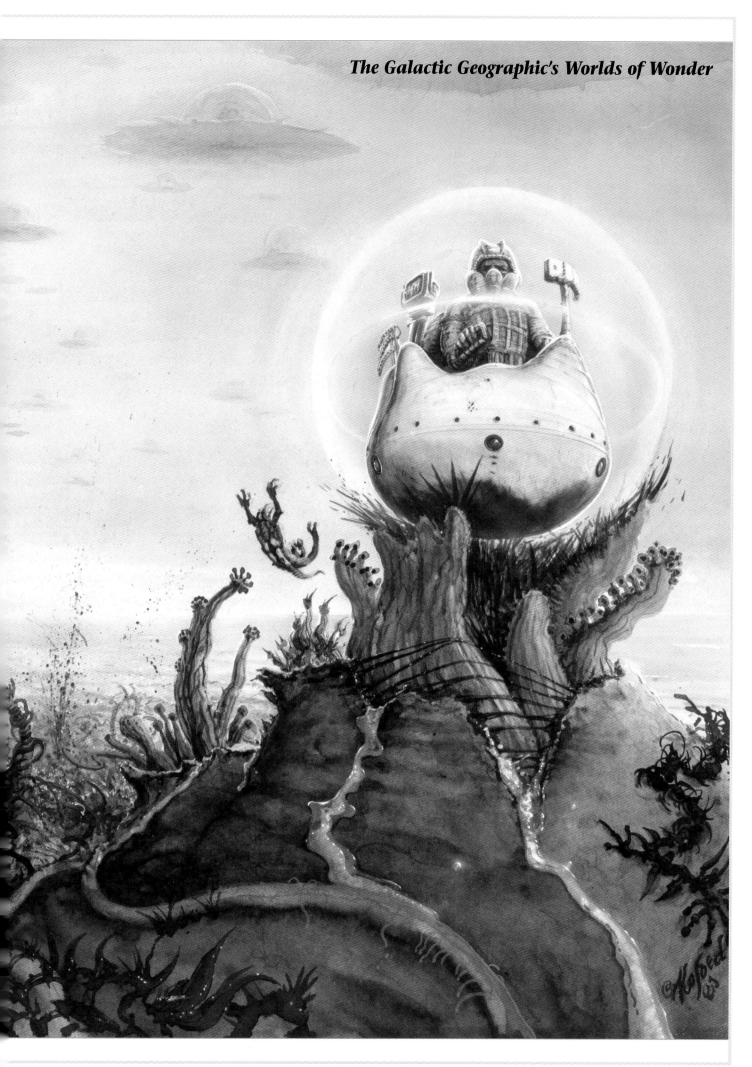

THE ROPE MAKERS OF BETEL 2B

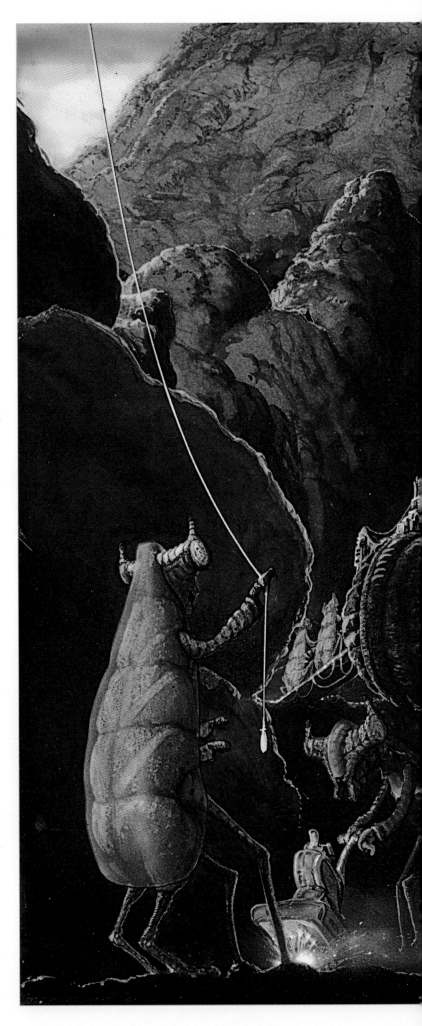

The creatures of Betel 2b, in the Betel-Majori system, are famous for a rope they make that stays flexible in extreme cold. In fact, they owe their lives to it. The rope secures their homes to the rocky outcroppings that typify their planet's rugged landscape.

Poisonous to Humans, the methane atmosphere of Betel is fresh air to the native Kriks, who manufacture the rope from a fungus that also provides their food. Waste material left over after the fungus is harvested and processed is used to make the lightweight, super-strong rope in furnaces like the one shown here.

In the foreground two Kriks use Federation supplied tools to anchor a rope into solid rock, preparatory to construction on the cliffs above.

Since the Federation's discovery of their world the Kriks, whose name comes from the sound made by their hind legs, have enjoyed an altered lifestyle. The translucent "clothes" they are wearing, for example, are of Federation manufacture, designed to protect the Kriks during the methane ice storms that pelt the landscape with needle-sharp hail as seasonal flooding forces the population to high ground. While their tough skin is well adapted to harsh conditions, the Kriks enjoy the added measure of protection and warmth the new garments provide.

The fungus they feed upon grows in ground-level caves during their summer, while the Kriks wait in their lofty dwellings for winter to freeze and stabilize Betel 2b's oceans. Only then is it safe to return to the ground, where they find shelter from winter's icy winds and warmer soil in which to grow their food. When the season turns warm again they make their rope and begin storing the ripened fungus in lofty homespun larders.

While trade relations seem to serve everyone's needs, Federation experts fear the Kriks may be unwittingly trading away the lifelines that assure the survival of their species. Researchers note that some of the larger Krik communities are already threatened by diminished stockpiles. Though aware of the situation, the Kriks seem unwilling or unable to increase their production to compensate. Hopefully, the Federation will find a way to correct this problem. If not, they may be forced to curtail trade with Betel 2b.

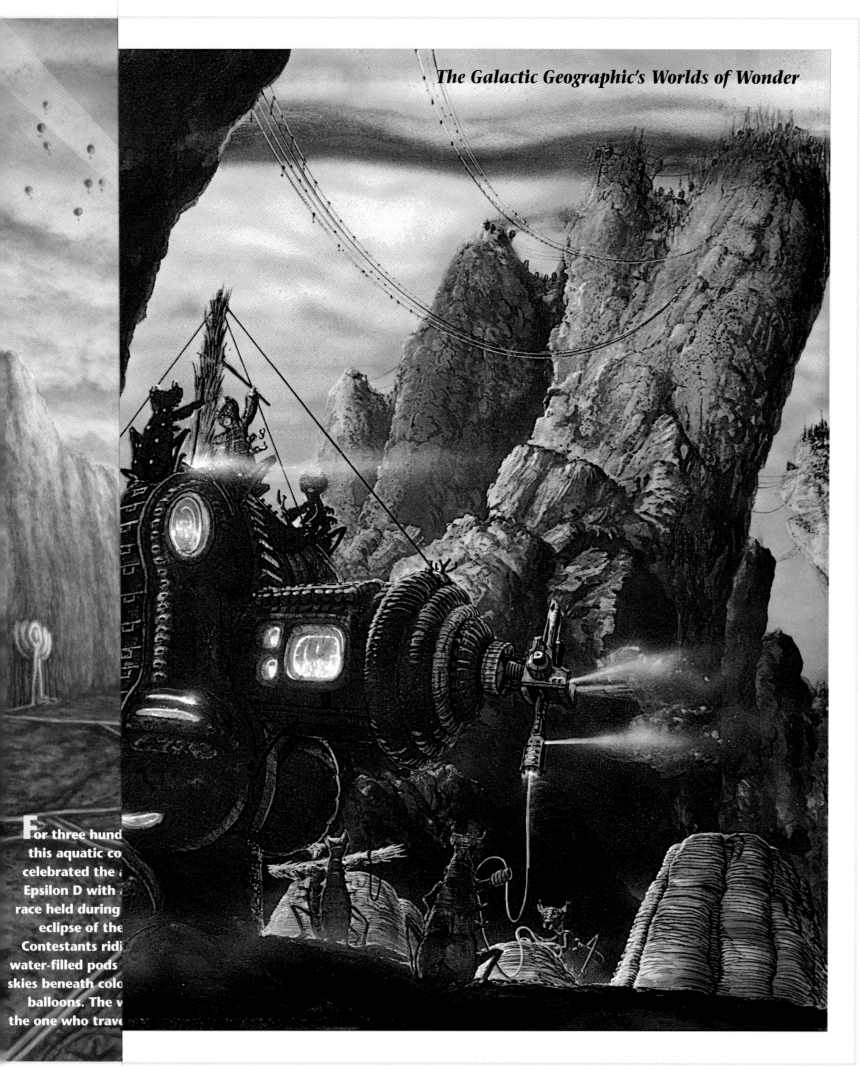

For three hund
this aquatic co
celebrated the
Epsilon D with
race held during
eclipse of the
Contestants ridi
water-filled pods
skies beneath colo
balloons. The v
the one who trave

BA

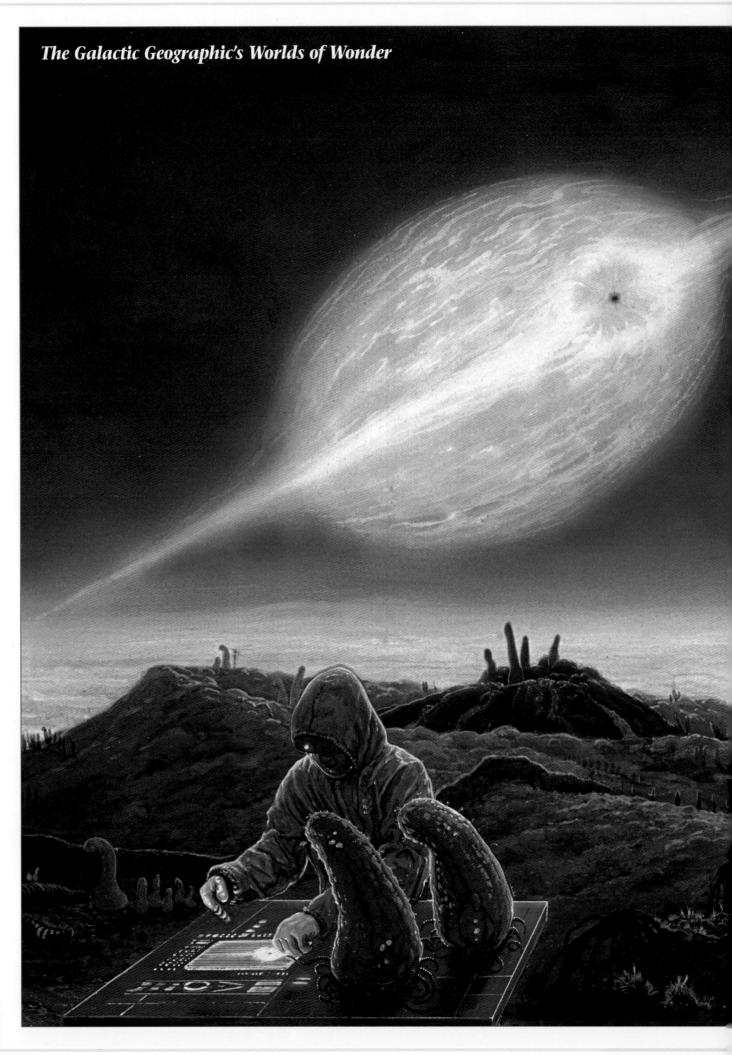

P asse
than
colony c
of colon

"I
the ballo
Rose, Su
Enceladu

Th
years fro
lifeless sy
and a fe
carbon c
was surv
for color
surface a

"It
'*Barren*,'
"Our sh
the surfa
... routir
the sky
colors ai
hanging

"T
descent
least fifty
by our s
ogist sug
the wind
source c
That's h
the Nor

It h
the aqua
they car
a stone,
And it is
allowed
home p
ocean, t
of world

Or

RESCUE FROM A BLACK HOLE

Lured here to investigate the source of a burst of radiation, a Federation research group aboard the SST *Wilson* probed a system invaded by a wandering black hole, and stayed there to observe and measure its effects.

They found, to their dismay, an entire planetary system being slowly eaten alive, and immediately began a survey of the planets, finding an Earth-sized planet populated with lifeforms unlike any previously observed. The *Wilson* undertook a rescue operation and found a small but typical colony of animals of a size suitable for transport. In this picture a technician wearing a Radsuit uses a scanner to examine two small creatures for damage due to radiation. Because of their planet's slow rotation, the animals had received little. They are shown observing their altered star, possibly for the first time.

The crew excavated the mound, moving it whole – with a large sampling of the soil and lifeforms – into the ship's hold. Surprisingly, the crew encountered no resistance to the intrusion, and the operation went smoothly.

With the added weight, however, the *Wilson* found itself bound by the gravitation of the double star. To escape, the ship had to accelerate toward the black hole, passing close enough to use its gravity to whip the ship to escape velocity. The perilous maneuver proved successful but the acceleration was too strong for some of the creatures, particularly the jelly-like mass that served as the center for the colony. Happily, most of the animals survived the transplantation to the Myhr Zoological Gardens, where a fresh mound was cultivated from spores of the old one. It can be visited by the public in its new permanent home inside Myhr Mountain.

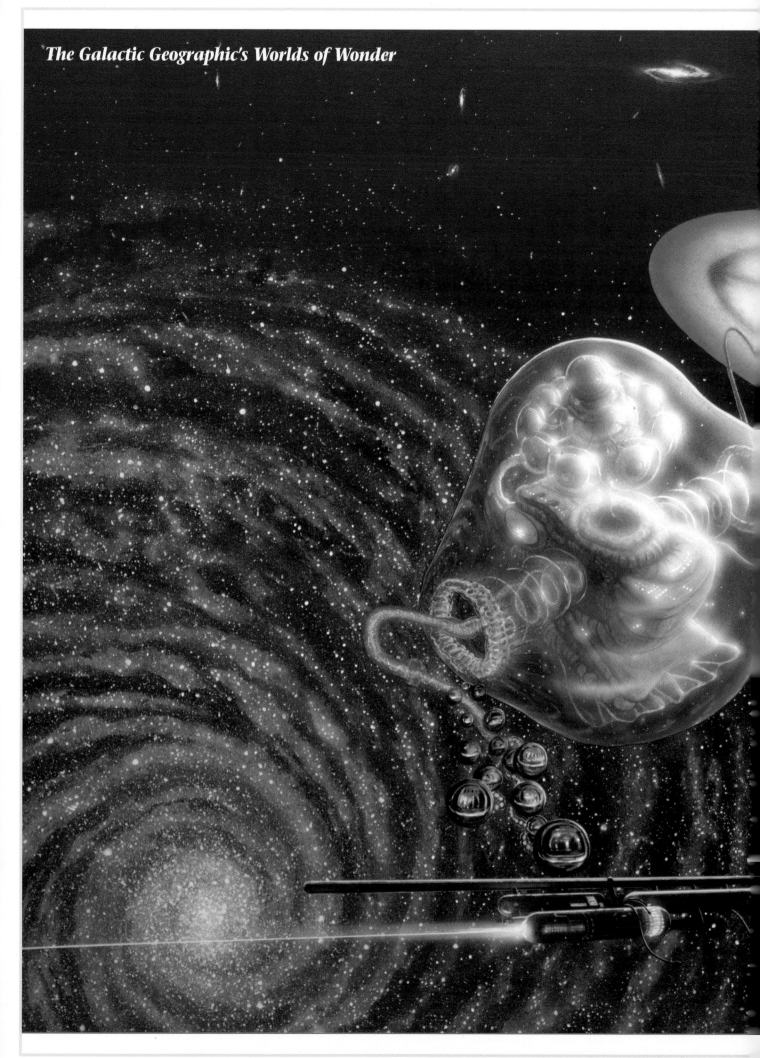

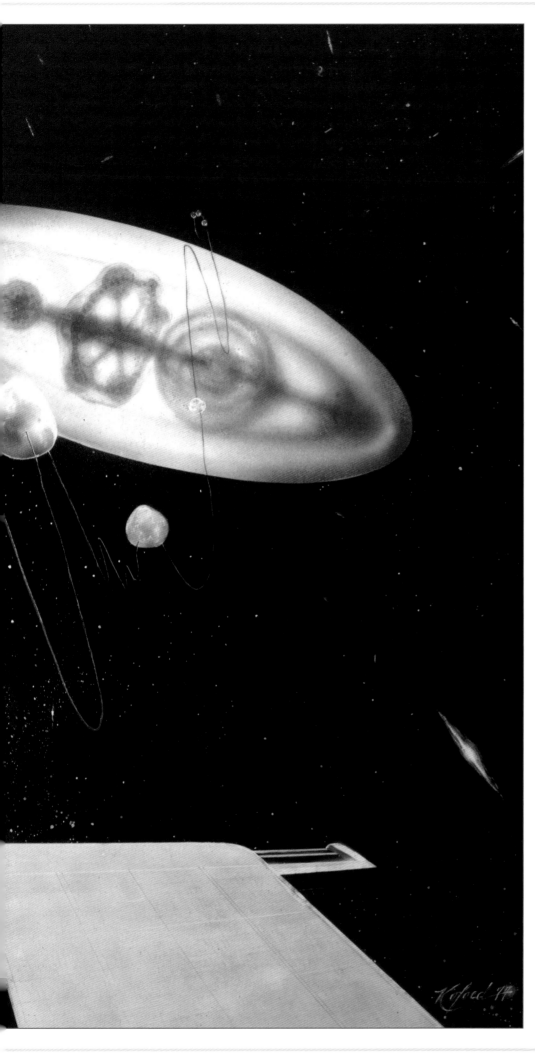

LIFE
IN THE VOID?

An alien lifeform appears where none should exist in this image transmitted from *Far Quest 6*, the first Federation manned vehicle to explore intergalactic space.

An automatic camera monitoring their still experimental tachyon transmitter *(foreground)* recorded this image, and a phenomenon that stunned the Federation. A technician aboard who witnessed the event gave the following account:

"I was watching the Milky Way while waiting to pull in the boom when I noticed the unit was discharging brightly. Past it, far away, I saw a light coming toward us. I knew nothing could be out there, but ... there it was. By the time I'd reported it, the light had stopped advancing ... hanging in space about a klick away. It looked like a blob of liquid filled with colored lights. Then a string of bubbles shot out ... so quickly that I jumped back. As I got back to the window, the bubble on the end stopped about a meter from the boom and just hung there. It made a quick, twisting move that caused an opening to appear in its side. From that opening came an appendage that produced small colored globules, like eyes, that floated for a few seconds examining the transmitter. Then it drew away and, like that, it was gone."

Scientists examining the recordings (from which this color scan was made) have suggested that the craft is biological or a symbiotic mix of animal and machine.

Robert Goddard, father of Human space flight, observed, "Every vision is a joke until the first man accomplishes it." Before us here, in the void between the galaxies, is an entity whose presence testifies to the limits of our understanding.

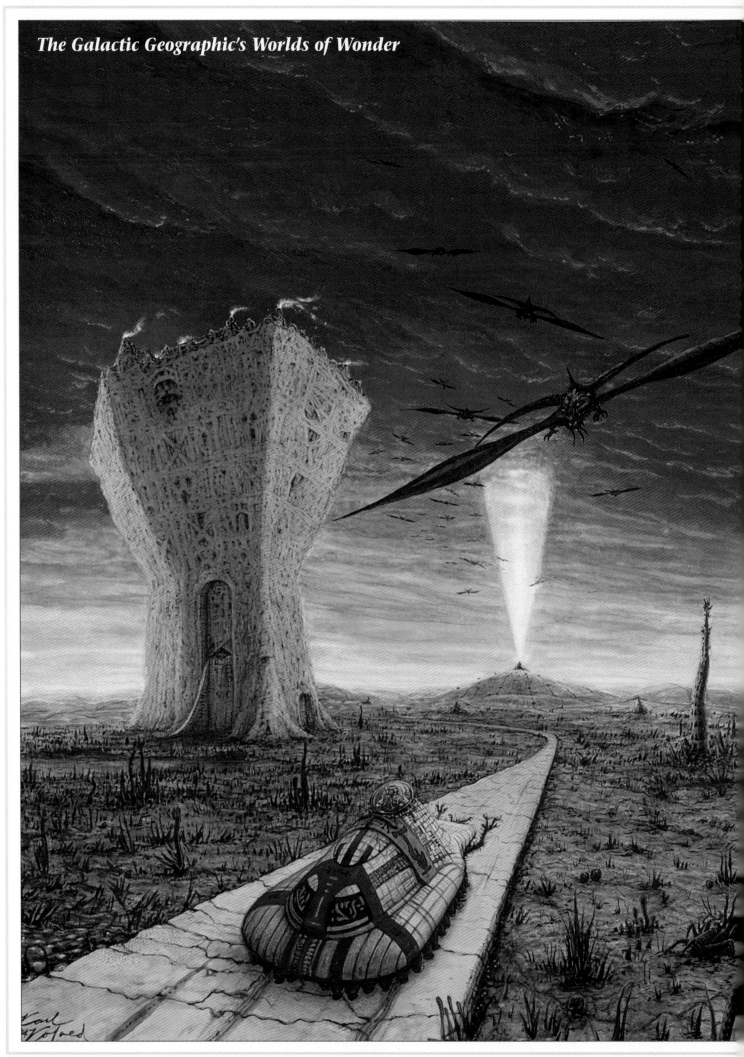

THE STRANGEST OUTPOST

Concluding the *Worlds of Wonder* series, the *Galactic Geographic* looks at one of the most puzzling worlds of all. To colonists on CeiTai Folix the inexplicable is routine.

Perhaps the most intriguing of Human outposts is a world at the fringes of Federation space.

Discovered over seventy years ago by Tsailerol sublight cruisers, the world they named CeiTai Folix is aptly described by the name's translation, "Place of Riddles."

"When you go to a planet you expect to make an impact on the lifeforms you find there. But after a year on this planet I'm still not sure the inhabitants are aware of us," says Jeth Danziger, shuttle pilot for the CeiTai Folix colony. As for all colonists, avoidance and non-involvement with the "locals" are the order of the day for the people here. Usually the Colonial Imperative is the hardest rule to follow, but for the 37 Humans and Tsailerol living in this single outpost on CeiTai's equator, the problem seems to be the opposite.

Pictured on the opposite page are two of the many peculiarities that abound on this mystifying world. What seems to be a castle or intricately carved monolith is really a sort of factory or machine whose purpose is still unknown. What appeared to be an ornately styled doorway turned out to be just an inset of carved stone.

The roads are another of this world's mysteries. There are thousands of them and they cover great distances. One roadway was traced for over 2000km before ending in a swamp. Like all the roads, it seemed to lead nowhere.

Then there are the creatures that travel the roadways. They come from the marshes and swamps and appear to be amphibious, since they seem undaunted by liquid or dry environments. Yet to be observed are any feeding or mating habits. They move slowly and make no sound.

None of these black, formless creatures has ever been seen on the roadways without a strange decorated shell, like the one shown here. Note that something resembling a head protrudes from the upper front, and grasping arms

wave continually as it moves. And it moves slowly, stopping every hundred meters or so, then moving on, leaving green trails of slime where it stopped. Rain causes the excrement to dissolve and spread out, becoming another layer of road surface.

It is assumed the creatures built the roads in this way. But their purpose remains a mystery.

"We [used the roads] ourselves and encountered [one or two of the] beings. They [do not] mind our [being] here, [but] don't move [out of the] way, either," says JsG15[RegTsai], a Tsai colonist and offspring of the planet's discoverer, STsG5[RegTsai].

Another oddity pictured here are the flocks of bat-like animals which appear threatening but are not predatory. Occasionally they can be seen sweeping over the marshlands. Since no specimens have been studied, these too remain a mystery.

The CeiTai Folix colony seen in the inset, and in the distance in the larger picture *(opposite page)* is self-sufficient and keeps in close contact with an orbiting station in space. The beam of light is a laser floodlight which serves two purposes: to sterilize gases ingested from the environment for use by the colony, and to insulate a tachyon communications beam so that it won't react with the atmosphere. The laser is used only when necessary and switched off if flocks of "bats" are in the area.

Colonial life is usually hazardous duty. But on CeiTai Folix, fear and caution are replaced by puzzlement and wonder. "We'll eventually unlock the secrets of the towers and the roads," noted a colonist after spending a year studying the planet. "Life-bearing worlds are like single organisms. To understand them, you have to learn how all the parts work, and then how they all work together. It takes patience. And lots of time."

◆

A Federation FTL cruiser departing for some stellar destination passes above the *Gateway Arch to the Universe* on Jupiter's tiny moon Amalthea. The monument is a symbol seen by many galactic tourists traveling to and from our solar system.

The bridge, over three kilometers tall, was built in 2880 as a structural experiment using polyceramic radiation-resistant materials, and also as a symbol of mankind's passage to the stars. It is likened to the St. Louis Arch on Earth – built in the late twentieth century – which symbolized expansion and trade for settlers of the American West.

At the dedication of the Amalthean Arch the President of the Federation signed the controversial Colonial Imperative forbidding cultural intervention or annihilation, traditionally byproducts of expansionism. *"The old ways of trade growth often involved war,"* he said, *"but now we embark on a new road, and the peoples encountered along the way should always see the best in us. This requires dedication to knowledge acquired through, and guided by, the steady hand of scientific inquiry."*

The Amalthean Arch

A bridge to nowhere –
more than just
an engineering marvel.

The Colonial Imperative: On Trial

When mankind embarked on missions to other stars we entered a new era, technologically and sociologically. During all of Human history any act, friendly or otherwise, was confined to our world. Conflicts that arose, however destructive they might have been, were damaging only to ourselves and to the Earth.

The advent of space exploration forced mankind to change. The Colonial Imperative has stood as a prime directive underscoring all relationships with aliens, both sentient and non-sentient, since Human colonization of other worlds began, over a hundred years ago. Put simply, protecting indigenous life is a colonist's first priority.

But the resolve underlying that rule is being tested on a mineral-rich moon called Epsilon Prime. There, colonists live in settlements far above the ground to avoid chompers. Also called chomps, the half-meter-long beasties snatch hapless surface prey into the soil. It is easy to lose a shoe, or even a leg, to these ugly carnivores, so colonists never walk unprotected on flat ground.

"Maglev boots cost a fortune," argues Anthony Sciarra, elder member of the largest Epsilon colony. "The painting might not be politically correct but it sure is popular with the folks on Epsilon Prime."

Sciarra is referring to the image on the opposite page that depicts a supposedly popular activity called "popping chompers." It under-scores a growing defiance of the Colonial Imperative. In Col Yardley, the main colony on EP117, the picture documents a practice that makes light of a dreaded foe that has forced the colonists to live only on large rock pinnacles.

Mining is accomplished with machines and ground workers must be protected by armored suits. The painting, shown on the opposite page, shows armor-clad colonists uprooting chompers with pointed poles, then using them for target practice (presumably with contraband weapons).

While the practice has never been officially documented, travelers have reported that areas of the planet's flatlands are being "cleared for settlement."

"I've lived alongside the colonists as they tried to live comfortably in homes hewn from solid stone," writes Karl Kofoed of the *Galactic Geographic*. "I under-stand their frustration at being unable to farm the richest soil in the quadrant. I have also seen a child lose a limb to these underground monsters. But I still think that the Colonial Imperative is the path we must follow.

"When we left Earth, we all became ambassadors. On alien worlds we risk endangering a planet when we serve only short-term needs."

Kofoed admits that the question is strictly a moral one, between each colonist and the Universe he or she believes in.

"Policing the Colonial Imperative is impossible. It's an etiquette colonialists must follow. That's why the laws governing appropriate behavior are in every Federation handbook aboard every starship in the fleet. It is also the only reason we are allowed to live among the Noron or the Tsailerol."

Meanwhile, science may have found an answer for the colonists' situation on Epsilon Prime. Already under test is a device that works slowly over time to make the chompers choose to avoid an area. Generating low acoustical waves, it makes these troublesome creatures move elsewhere, but leaves other lifeforms unaffected.

Presently employed only on a *Geographic* research site, the device may become a prototype for use all over the planet and even on other worlds.

"Chomper"

Subterranean lifeform digs holes to trap surface-dwelling prey.

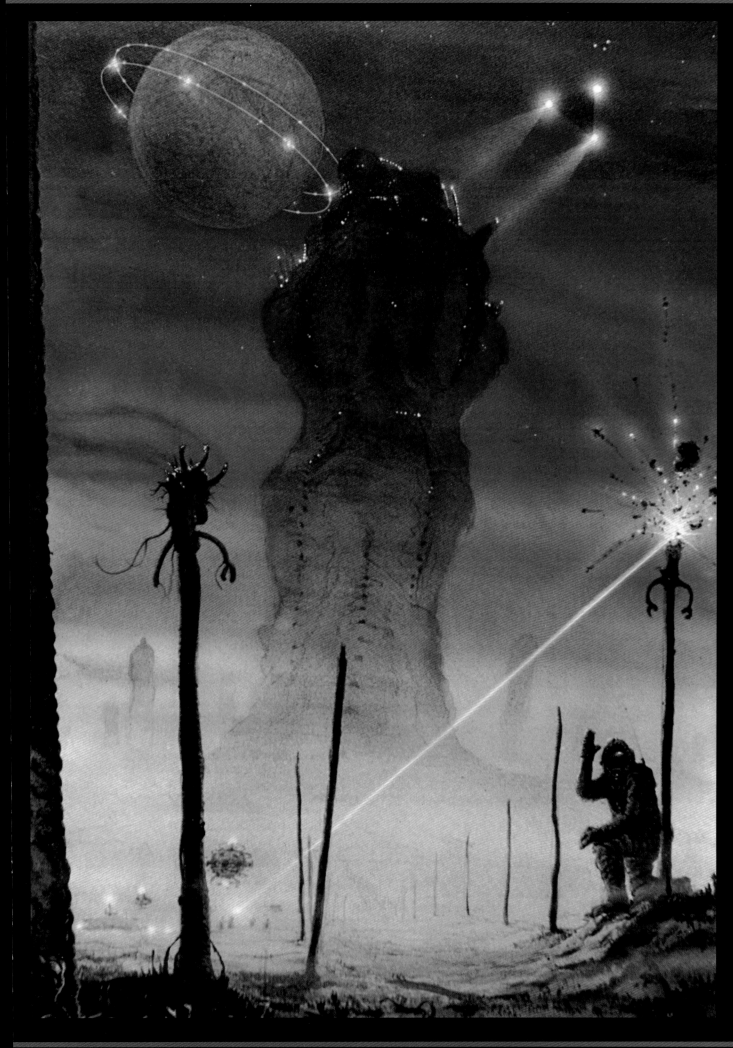

In **PROJECT NEPTUNE**
The Federation Grapples
With A Biological Threat

Defending Humanity?

"We're glad we found it as early as we did," says Capt. John Wysor of the Starship *Goddard*. His ship and others were sent to investigate a mysterious mass invading the outer reaches of our Solar System. "We watched as it adjusted course toward the inner planets," said Wysor in the press release that accompanied this image.

Dubbed "the mighty virus," the material is organic, and it may be growing. Scientific investigations have netted this description of the phenomenon: "There are over fifteen thousand units, each weighing over 10,000 tons. The frozen organic units are linked magnetically in a spiralling strand over 2000 kilometers in length."

Contending that the mass is already a hazard to shipping, the report concludes that it may be a greater hazard if left unchecked. Because research has disclosed that the material is growing, the Federation had no choice but to eliminate the threat.

A team of scientists prepares to leave the surface of the mysterious object in tow, while the ship fires a chemical laser. Critics say the action is premature – contending science has not proven the invader to be a genuine threat.

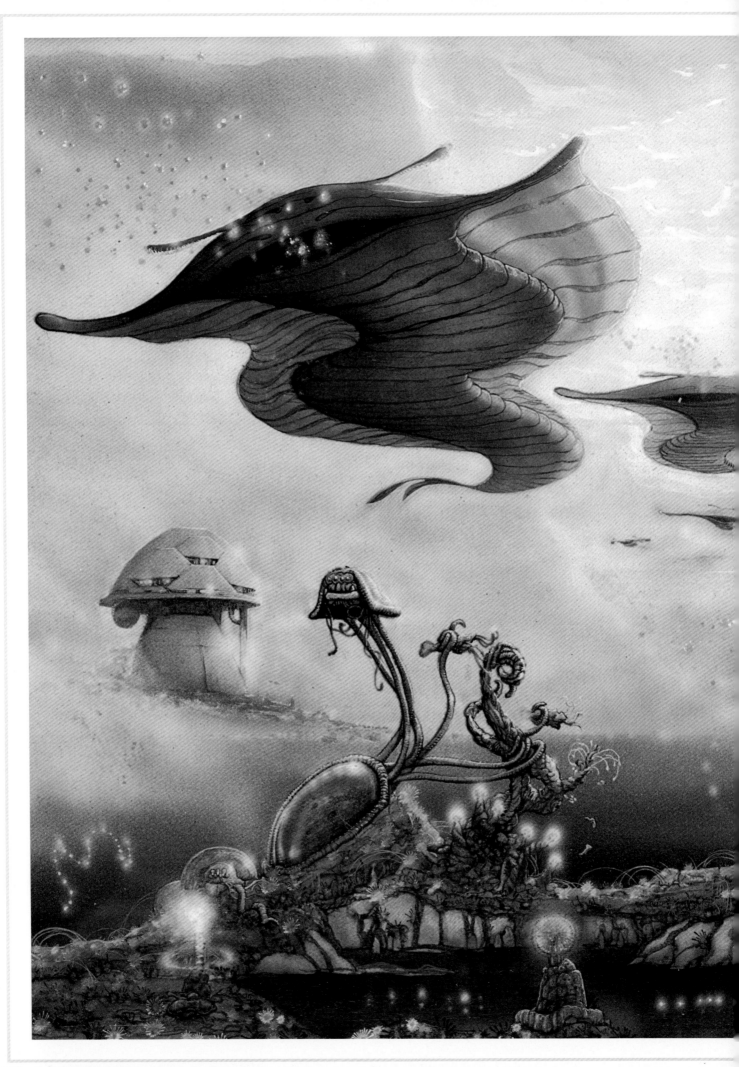

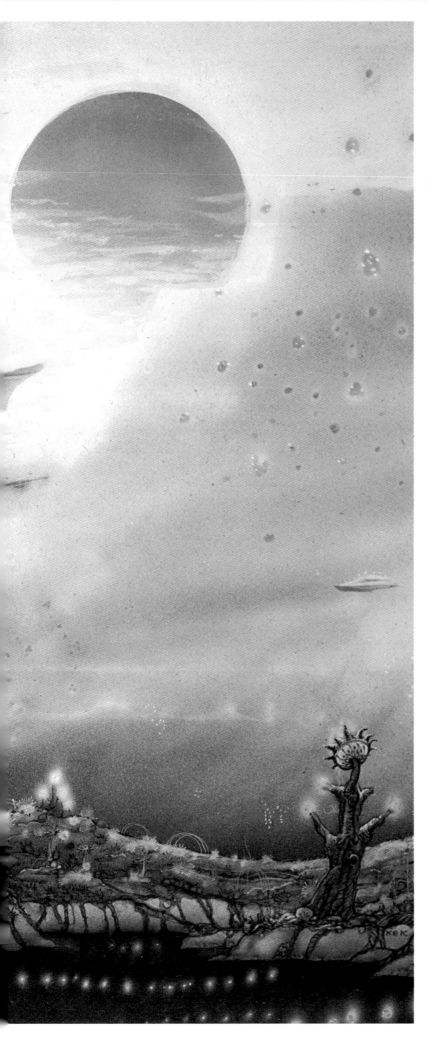

The Passing of the Airwhales

... marks the solstice at Point Benton Colonial Pressure Dome on the densely atmosphered planet Benton 2, named for its discoverer, eccentric explorer Scyr Benton. Its soupy atmosphere and profusion of lifeforms, unrivaled among the known worlds, led explorers to call the planet "Benton's Chowder."

Benton 2's climate tests the adaptability of its creatures. Summers there are balmy over most of the planet, with temperatures near 30°C, but the planet's elliptical orbit and axial tilt produce cold winters for the northern hemisphere, where carbon dioxide snows often dust its pole.

But at the equator life continues year round. Winter's onset sees the airwhales terminate their migration and funnel into feeding grounds through a pass in a cliff-like ridge that shelters the area from a cold and hostile sea.

Airwhales feed on clouds of floating algae. To locate their prey in the misty atmosphere, they emit a droning sound audible for hundreds of kilometers, which excites the algae to a luminescent state, making it highly visible.

In this typical summer scene at Point Benton, the damp ground is abloom with firepods, source of the algal swarms and favored food of the shelled roper seen in the foreground. This one, dining on a fresh firepod, watches an airwhale pass overhead. The roper moves about by grasping and pulling with rope-like appendages.

In the foreground is what seems to be a quiet blue pond. Blue it may be, but a pond it is not, and scientists are baffled by it. Samples have never been taken of this flat blue thing, whose velvety surface either shrinks away from probes or ingests them. Any small metal object tossed onto the pond will lie undisturbed for eight to ten seconds, then sink below the surface, only to reappear sometime later along the pond's perimeter. Organic objects are ingested similarly but do not reappear. If probed insistently, or cut by laser, the pond will suddenly seep into the ground.

In northern climates the roper closes its shell to winter's cold, looking like nothing more than a common stone. The firepod dies and its body turns to powder in the ice storms of winter, only to live again when warm spring rains wash its spores into the soil.

(continued)

by **Karl Kofoed**, Galactic Geographic Society

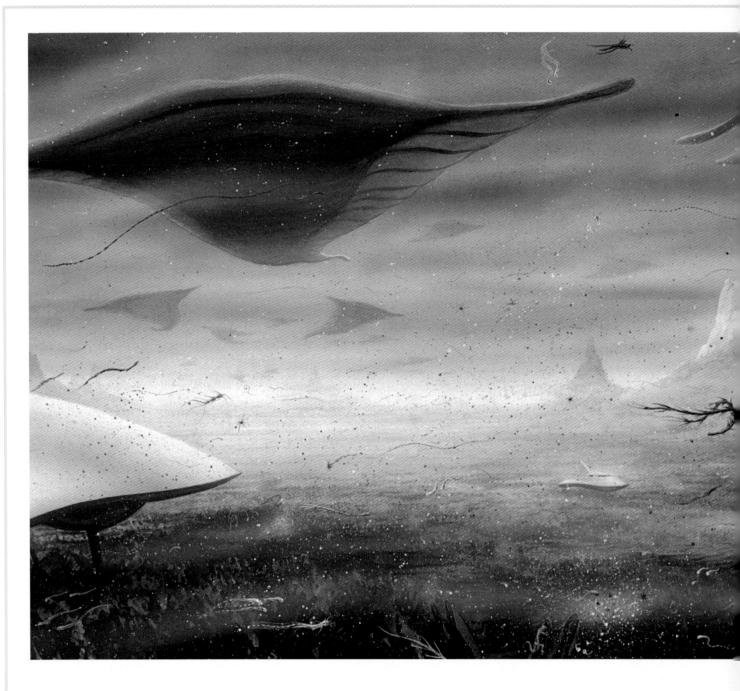

Our research colony on Benton devotes most of its efforts to studying the ecosystem of the 2500 sq. km feeding grounds, a vast marshland which contains lifeforms of such variety and complexity that after six years on Benton our scientists have only begun to unravel some of its secrets.

One mystery which may be solved is the question of why the airwhale population is diminishing at the rate of about 8000 per year. (Benton's year is 1$^1/_2$ Earth years.) It alarmed our researchers to discover this in the midst of what seemed a stable ecology. Unless current trends change, the airwhales could be extinct in less than 200 years. In 2942, Benton's early explorers estimated the airwhale population at about two million. As this article is published, the number will have diminished to 1.6 million. *(See GG Tape 31075-B25573 "Airborne Worms of Benton II" by A. D. wl. P'rees.)*

The reason for the diminishing herds, scientists believe, may be attributed to seawater slowly seeping into the marshlands. This condition, they fear, may eventually poison the fertile marsh and erode the breakwall which protects it from the sea.

Already the marshland is dying and the algal swarms are decreasing in numbers and receding deeper into its interior. Thus the food supplies of the airwhales are threatened.

Are the airwhales to be Benton's dinosaurs? Visitors to the feeding grounds would hardly think so were they to witness the scene shown at the beginning this article. The picture displays the marshlands in full bloom. Painted from a field sketch by colonist-researcher Quentin K. Thompson, the image clearly illustrates the feeding grounds' astonishing profusion of life. Of the picture Thompson noted, "I could never conceive a more abundant nursery for life. Day and night during summer the air resonates with the song of the herds and all manner of life dances with excitement to that music. At night the glowing clouds of algae set the landscape aflame with color. One cannot avoid a sense of awe while watching the sparkling swirls being swept up by the massive airwhales as they feed."

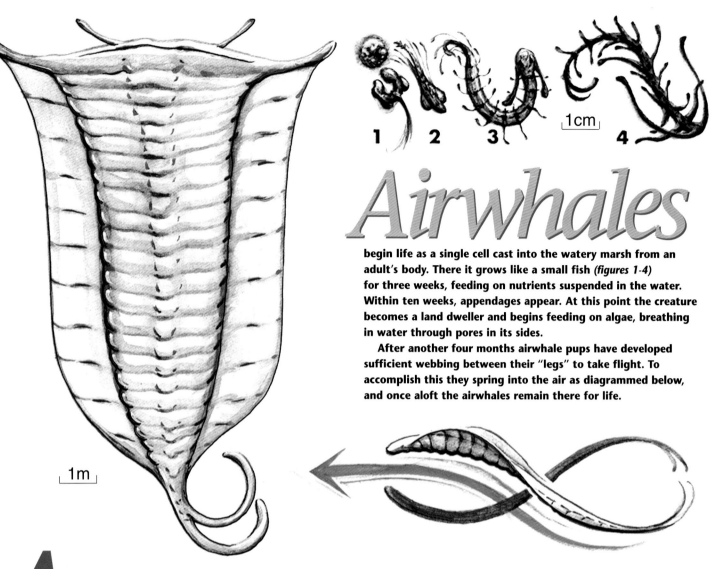

Airwhales

begin life as a single cell cast into the watery marsh from an adult's body. There it grows like a small fish *(figures 1-4)* for three weeks, feeding on nutrients suspended in the water. Within ten weeks, appendages appear. At this point the creature becomes a land dweller and begins feeding on algae, breathing in water through pores in its sides.

After another four months airwhale pups have developed sufficient webbing between their "legs" to take flight. To accomplish this they spring into the air as diagrammed below, and once aloft the airwhales remain there for life.

Airwhales fit their name. An adult can measure more than twenty meters long. Each segment of their bodies contains a chamber filled with a froth of hydrogen bubbles. With their weight counterbalanced by these chambers, they have little trouble staying aloft, even after a full day's meal. They feed by floating through swarms of algae with their mouths agape, like Earth's baleen whales. Air passes through their mouths and exits through openings between their first and second body segments. Algae are trapped in the sticky lining of the air-whale's gullet, then pass into the stomach. Airwhales store their food as a light oil which provides a matrix for the hydrogen bubbles in their flotation chambers. In the sketch at right a biologist examines the remains of an airwhale to determine its cause of death.

Airwhales consume nearly two tons of algae daily at the height of their feeding. This may seem like a large amount, but current estimates indicate that, despite reduced algae supplies, there should be more than enough to sustain the biological balance of the marshlands. Starvation of the airwhales, at least for now, should not be occurring. This leads some to wonder if the airwhales are reducing their numbers in anticipation of food shortages. It has been suggested that evolution has given them a mechanism for governing their activities as individuals and as a group, a form of communal instinct that not only regulates their feeding and birthrate, but also guides them through their complex migratory cycle.

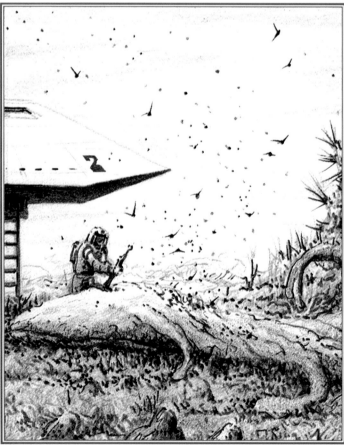

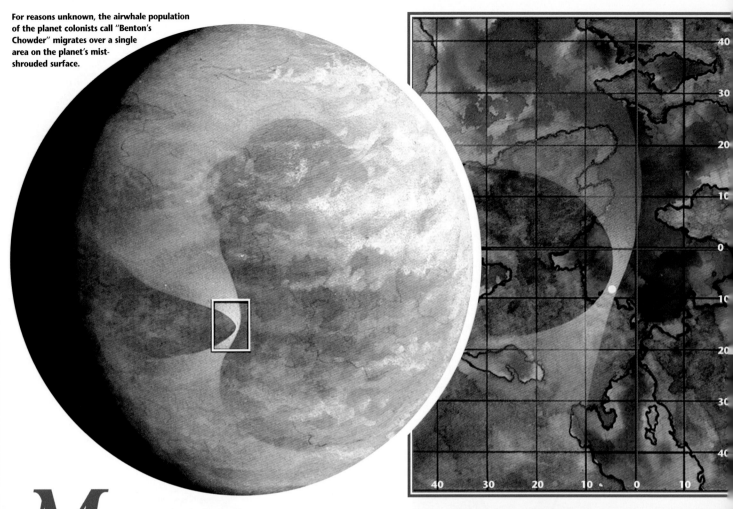

For reasons unknown, the airwhale population of the planet colonists call "Benton's Chowder" migrates over a single area on the planet's mist-shrouded surface.

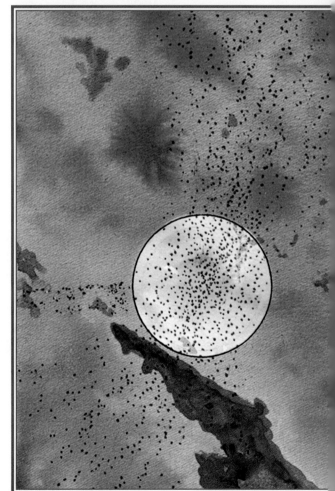

Migration patterns, feeding habits, and their strange song are characteristics which led to the airwhales' name. On the cloudy globe of planet Benton, pictured above, the area where all migrating airwhales funnel into their feeding grounds from the northern hemisphere is marked by a white rectangle. At the top right is the same area enlarged. A white dot marks the spot through which the airwhales pass. It is not the break in the seawall, as described before, but a zone 40km wide located about 100km north-east of the seawall. This may be where the airwhales orient themselves for the passage southward into their feeding grounds. A satellite view *(at right)* shows the same zone, enlarged. The airwhales can be seen as tiny red dots on the infrared image.

Just ahead of this spot is the airwhales' first landfall after crossing over 1000km of ocean. The landfall is part of an island chain that encloses a bay sheltering the entrance to the feeding area. Each year the herd streams into this area from the northern hemisphere for a period of 8-12 days. Once in the marshlands they graze for four months while young airwhales are born and mature. At the end of this time the entire herd begins fanning out, remaining over land in the southern hemisphere. Seven months after entering the feeding grounds, the herd has absorbed enough food to begin the slow migration to the northern hemisphere where summer heat and rains have allowed algal clouds to grow. By this time the airwhale herd has dissipated into small groups. They feed only occasionally, drifting lazily across mountains and valleys, following instinctively a path that can cover 200,000km by the time they return to their winter refuge.

Benton is nearly the same size as Earth but twice as massive. This, coupled with its increased spin, produces gravity 1½ times that of Earth, making Benton uncomfortable for new colonists accustomed to the weightlessness of space travel. They must spend at least a month in colonial pressure stands adjusting to Benton's gravity before donning protective suits and venturing outside, where they encounter difficult terrain and an atmosphere 3½ times denser than Earth's.

The planet has a geology resembling Earth's. Its solid core, molten mantle, moving outer crust and global oceans invite comparisons to Earth. But Benton's geology is older than Earth's, with less volcanic activity and a slower continental drift.

Abundant water is Benton's primary assurance of continued life. Its shallow oceans are teeming with lifeforms which scientists are eager to study, but for now that realm remains unexplored. The seawater is also similar to Earth's. It is salty but has higher quantities of dissolved methane and ammonia.

In spite of the differences between Earth and Benton, it is the similarities that make the biggest impression on resident scientists. After crossing the 293-light-year gulf that separates the two planets, one expects to find an alien world. So the explorer-colonists take the strangeness of life on Benton in stride. "We are here to learn," said Edward Strickland, commander of Benton's three colonies, "and what we are learning is worth the cost. In planetary exploration you expect the unfamiliar. It's the familiar that surprises you."

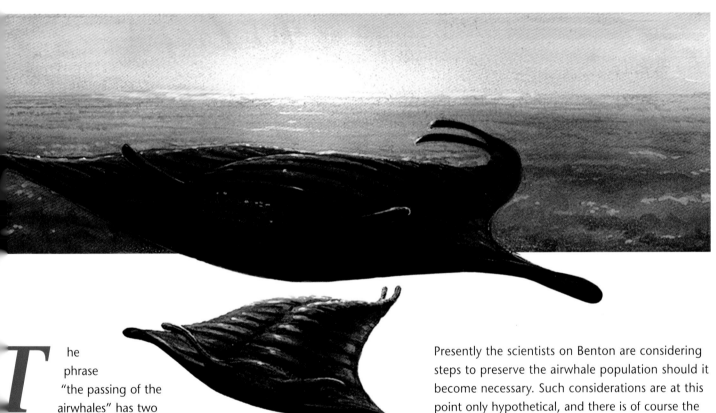

The phrase "the passing of the airwhales" has two meanings for those at Point Benton. Says Commander Strickland, "It means, of course, the time of year when the airwhales swarm into their feeding grounds. They make the strangest sound, and you can hear them coming long before they start entering the grounds. But that same phrase also reminds us that the airwhales' story may be only a brief chapter in the eternal struggle for life on Benton – a chapter that is about to end.

"Most of us on Benton have developed a special fondness for the airwhales. They are so much like the great whales of planet Earth that seeing them is somehow a reminder of home. Working in the field on Benton is strenuous to say the least, but most of us enjoy the work because we can be out there among the huge floating beasts and watch them feed and drift. As accustomed as we are to their presence, the fact remains that most of the colonists share a feeling of joy as we watch them."

Presently the scientists on Benton are considering steps to preserve the airwhale population should it become necessary. Such considerations are at this point only hypothetical, and there is of course the long-standing rule that Human exploration of other worlds must not interfere with the ecology of those worlds being explored. All that has ever been done to preserve endangered alien species is to relocate them in an artificial environment like those at the Myhr Zoological Gardens. Whatever the fate of the airwhales may be, for now the colonists on Benton are committed to the idea that the airwhales will continue to sing in the airborne oceans of Benton.

The image above, of an adult and infant airwhale against a sunset, is a favorite among Benton's colonists. Each pressure stand has a copy of it on display. The picture somehow blends with the many other pictures of scenes from Earth. Perhaps it captures something about life that is universal: the mother and child, companionship, or simply hope.

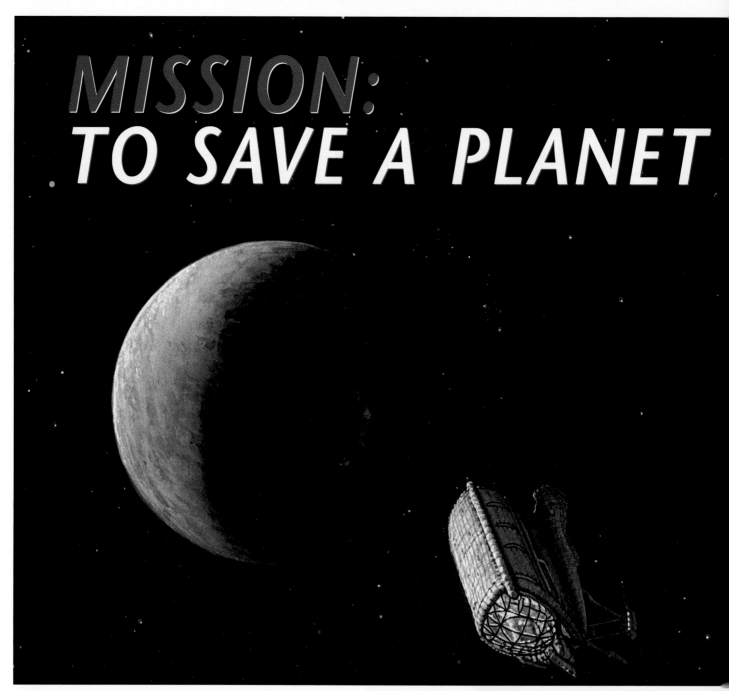

MISSION:
TO SAVE A PLANET

The Story of Project Noah –
the Federation's Effort to Save a Planet's Lifeforms from Destruction

When we learned that a collision between two worlds was imminent, the Federation starship *Houston*, like every other starship in the Federation of Worlds' sphere of influence, was asked to support a bold plan to remove as many types of lifeforms from a doomed water world as possible and to assist in their relocation to a suitable environment. The response was overwhelming. Over a thousand ships from the combined worlds rallied to the cause. This, then, is the first report of Project Noah, a mission to save a doomed planet.

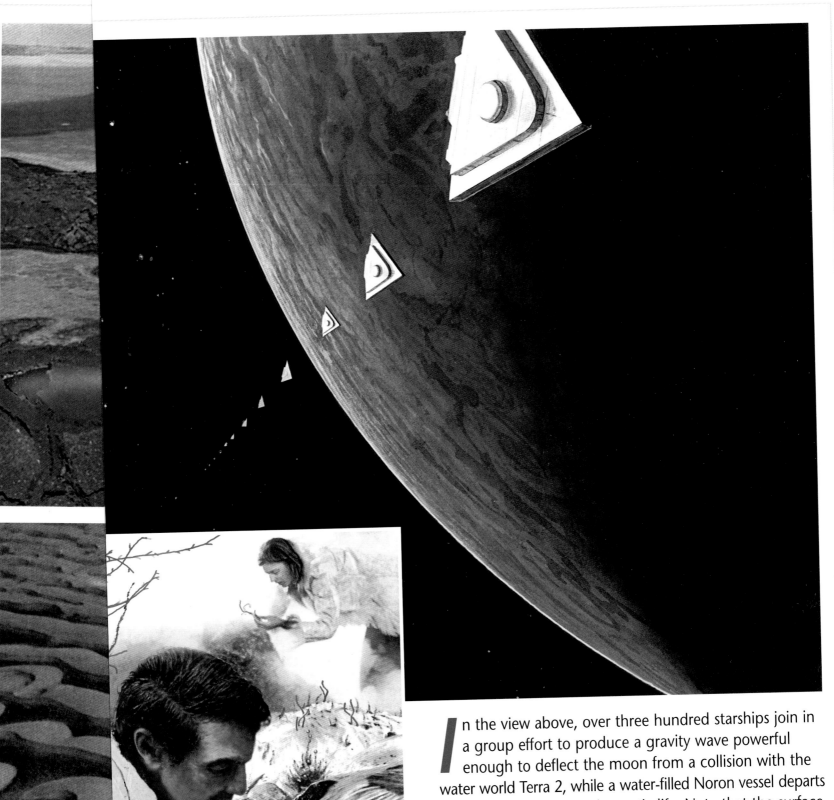

In the view above, over three hundred starships join in a group effort to produce a gravity wave powerful enough to deflect the moon from a collision with the water world Terra 2, while a water-filled Noron vessel departs with its cargo of rescued aquatic life. Note that the surface is already showing signs of tidal stress caused by the rogue moon. Because this maneuver had never been tried, the mission had to be completed before the G-Pulse rift was attempted. Assisting the Earth team's ocean survey is Peo, survey leader of the dolphin oceanic team *(opposite page)*.

Heading the land survey is Dr. H. Jaffossen, seen at left taking samples with his assistant. "In such a case as this," he observed, "when life is threatened on such a grand scale, and we have a way to preserve it, we must take whatever action is necessary to do so."

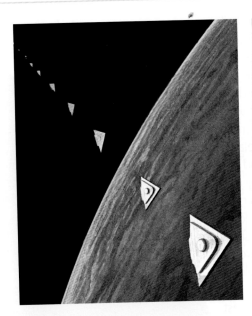

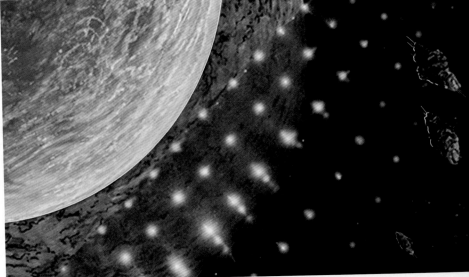

Compl
Terr
mou
rival

The G-Pulse drive, standard on all Federation starships, has more than enough power to catapult a ten-thousand-ton ship into C-space. So powerful is its effect that the drive is never used near planets for fear that it could disturb the stability of the entire system.

Scientists theorized that, when used in unison, the force of many combined stardrives might be enough to move a planet from its orbit.

But theory became necessity when we learned that a large rogue moon, deflected from its orbit by a passing star, was soon to collide with an earthlike water world burgeoning with life.

While bioscience groups planned Project Noah, engineers applied their skills to "Project 8-Ball"– a reference to the ancient game of Billiards or Pool.

Shown here and on the next page are images from Terra 2's last moments. "The G-Pulse worked very well, but its effects were too little and way too late," said a frustrated Carol Kelly, Chief Engineer aboard the *Abrams*.

"The combined energy of over three hundred ships stopped a head-on collision and turned it into a near miss. But they couldn't prevent the destruction of both worlds."

GG FED NOAH 23117-3094-2-13 • 1175.132 • 84812

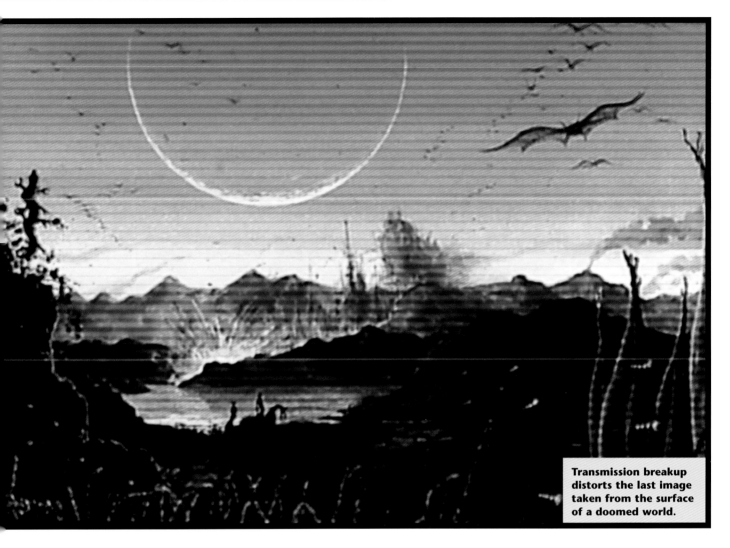

Transmission breakup distorts the last image taken from the surface of a doomed world.

We put automated cameras and rovers at selected spots all over the living world to record its last seconds.

"The immense scope of our project was beyond everyone's expectations," said Ms Kelly. "Our planners did a great job but there were never enough materials on hand to do our job. This applied to everything: ships, people, cameras, coffee, power ... everything!"

At right is an image taken from a Tsailerol ship of the moment of collision as two atmospheres are suddenly compressed and heated in a microsecond to the temperature of a star. The resulting explosion (*shown on the facing page*), only a millisecond later, shattered both worlds.

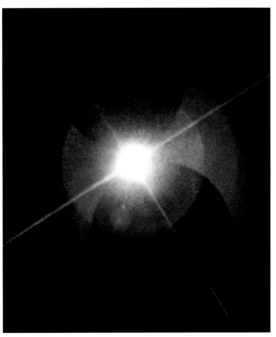

"While cameras faithfully caught the tragic event in all its macabre glory, few of us could bear to watch," noted Dr. D.S. Hoy, the team's chief biotech officer. "We knew we couldn't stop the collision but we had to try. I'm just happy to see how many lifeforms we were able to collect and preserve in so short a time."

Multiple teams representing three civilizations joined together for Project Noah, acting in unison for a common goal: the preservation of life.

Already over 80,000 different lifeforms have been salvaged from Terra 2. Some of these will occupy a newly renovated section of the Myhr Zoological Gardens on Earth. The rest will be held in stasis until a suitable plan can be devised to duplicate the world's many environments.

The Federation is trying to enlist the help of the WO super-civilization to create a terraformed environment from a lifeless moon in their system. Only they have the technology to accomplish a rapid worldbuilding operation.

The *Galactic Geographic* will be reporting in greater depth on the findings of Project Noah in future articles when more details become available. ◆

THE VISIBLE TSAILEROL

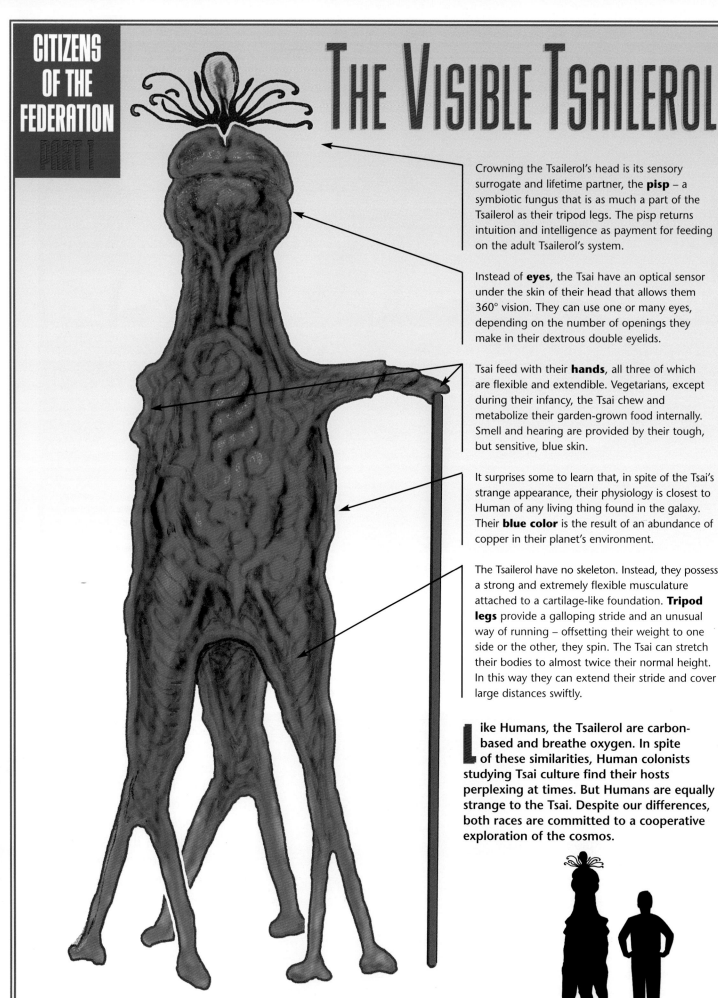

Crowning the Tsailerol's head is its sensory surrogate and lifetime partner, the **pisp** – a symbiotic fungus that is as much a part of the Tsailerol as their tripod legs. The pisp returns intuition and intelligence as payment for feeding on the adult Tsailerol's system.

Instead of **eyes**, the Tsai have an optical sensor under the skin of their head that allows them 360° vision. They can use one or many eyes, depending on the number of openings they make in their dextrous double eyelids.

Tsai feed with their **hands**, all three of which are flexible and extendible. Vegetarians, except during their infancy, the Tsai chew and metabolize their garden-grown food internally. Smell and hearing are provided by their tough, but sensitive, blue skin.

It surprises some to learn that, in spite of the Tsai's strange appearance, their physiology is closest to Human of any living thing found in the galaxy. Their **blue color** is the result of an abundance of copper in their planet's environment.

The Tsailerol have no skeleton. Instead, they possess a strong and extremely flexible musculature attached to a cartilage-like foundation. **Tripod legs** provide a galloping stride and an unusual way of running – offsetting their weight to one side or the other, they spin. The Tsai can stretch their bodies to almost twice their normal height. In this way they can extend their stride and cover large distances swiftly.

L ike Humans, the Tsailerol are carbon-based and breathe oxygen. In spite of these similarities, Human colonists studying Tsai culture find their hosts perplexing at times. But Humans are equally strange to the Tsai. Despite our differences, both races are committed to a cooperative exploration of the cosmos.

1m

THE AQUATIC NORON

The Noron of Epsilon Iridani are physiologically unlike any lifeforms found in Earth's oceans. Some compare the Noron to the octopus, both being soft-bodied animals with high intelligence. But the comparison is superficial and misguiding, for the Noron are more comparable to Humans or the Tsailerol, who have embraced technology and left the safety of their home planet to explore the stars. This is no easy feat for a creature who hasn't ventured onto land – the first step in the accepted theory of species evolution, which holds that technology evolves from the need for tools to survive a changing environment. Unlike Earth or the Tsailerol home world, there is no land on the Noron planet. An ice age, caused by an orbital shift of their planet, forced the Noron to develop an artificial heat source to survive a cooling ocean. Thousands of years later, they took to the skies, and finally to the stars.

Background: A Noron clan rings a floating egg cluster in an annual birth ritual.

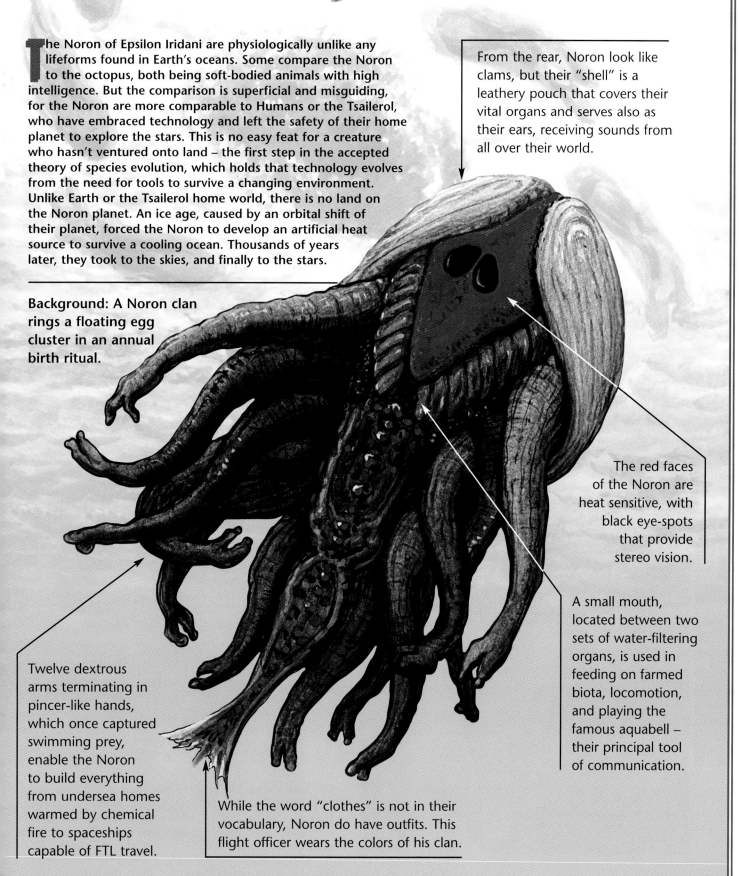

From the rear, Noron look like clams, but their "shell" is a leathery pouch that covers their vital organs and serves also as their ears, receiving sounds from all over their world.

The red faces of the Noron are heat sensitive, with black eye-spots that provide stereo vision.

A small mouth, located between two sets of water-filtering organs, is used in feeding on farmed biota, locomotion, and playing the famous aquabell – their principal tool of communication.

Twelve dextrous arms terminating in pincer-like hands, which once captured swimming prey, enable the Noron to build everything from undersea homes warmed by chemical fire to spaceships capable of FTL travel.

While the word "clothes" is not in their vocabulary, Noron do have outfits. This flight officer wears the colors of his clan.

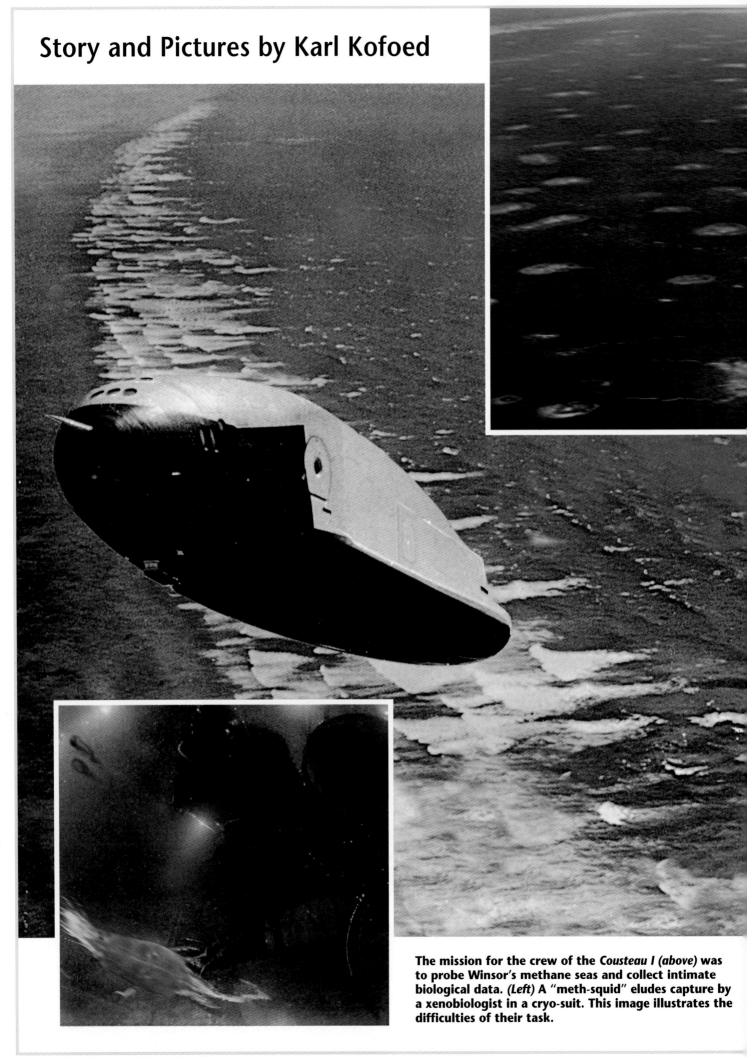

Story and Pictures by Karl Kofoed

The mission for the crew of the *Cousteau I (above)* was to probe Winsor's methane seas and collect intimate biological data. *(Left)* A "meth-squid" eludes capture by a xenobiologist in a cryo-suit. This image illustrates the difficulties of their task.

DIVING IN METHANE

The Cousteau Foundation explores a living cryogenic ocean 600 light years from Earth.

Life in liquid methane? Until recently the answer to this question lay hidden beneath the frigid waves of Winsor's liquid-methane ocean. These pages testify to the perils faced by a handful of explorers who, working under a grant from the Cousteau Foundation and the *Galactic Geographic*, have unlocked some of the secrets of life on a distant alien world.

The planet is one of three worlds known to possess oceans of liquid methane. But only Winsor, located in the Rigel star group, harbors life.

Discovered in 2942 by the FTL Starship *Kennedy*, commanded by William Winsor, for whom the planet is named, the planet had not been studied until now because of the extraordinary measures required to explore such a hostile environment.

The Cousteau Foundation of Planis, despite its experience in alien sea exploration, had to adapt its ships and equipment for an extremely cold world, a task that took over seven years. "We had little experience with cryo-diving because no ecology like this had ever been found," reports Admiral M'Yves Cousteau. "But with so much to study we were eager to undertake this two-year mission: a manned exploration of a cryogenic sea." The images on these pages testify to the extraordinary nature of planet Winsor and the dangers incurred studying her.

(Above and left) **Splashing down in an Aldyn V4 dive-shuttle among Winsor's living islands near the planet's equator, the crew, headed by M'Yves Cousteau** *(holding a tray of eggs at right)* **endured two years in a sealed environment to complete the mission.**

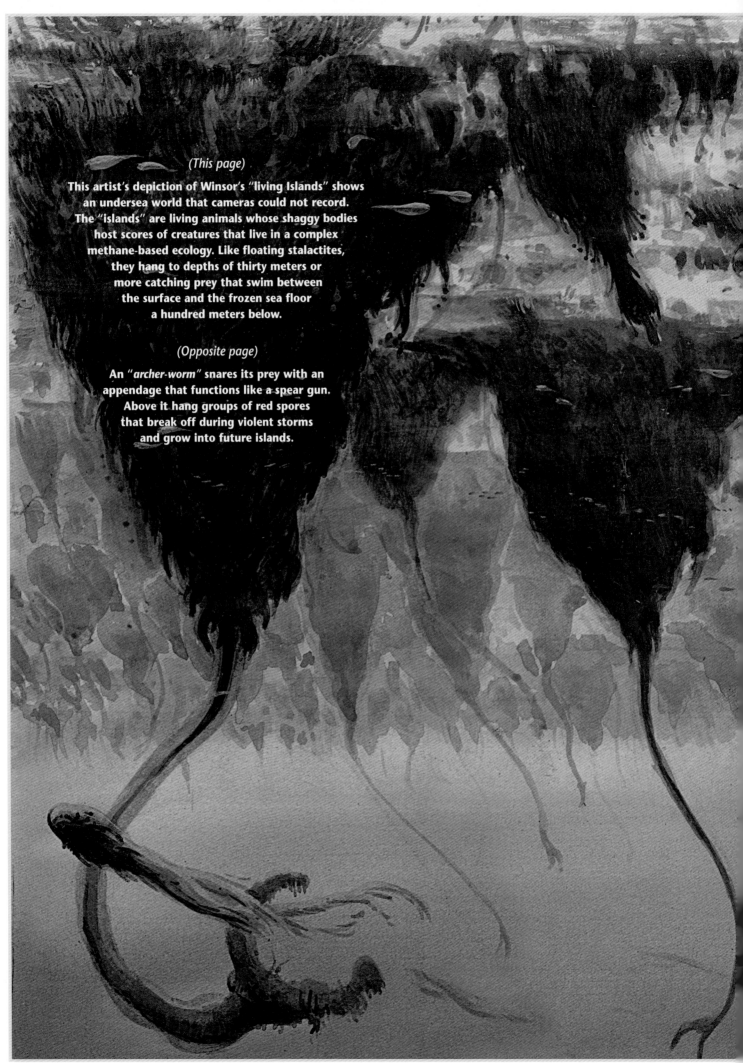

This artist's depiction of Winsor's "living Islands" shows
an undersea world that cameras could not record.
The "islands" are living animals whose shaggy bodies
host scores of creatures that live in a complex
methane-based ecology. Like floating stalactites,
they hang to depths of thirty meters or
more catching prey that swim between
the surface and the frozen sea floor
a hundred meters below.

(Opposite page)

An "archer-worm" snares its prey with an
appendage that functions like a spear gun.
Above it hang groups of red spores
that break off during violent storms
and grow into future islands.

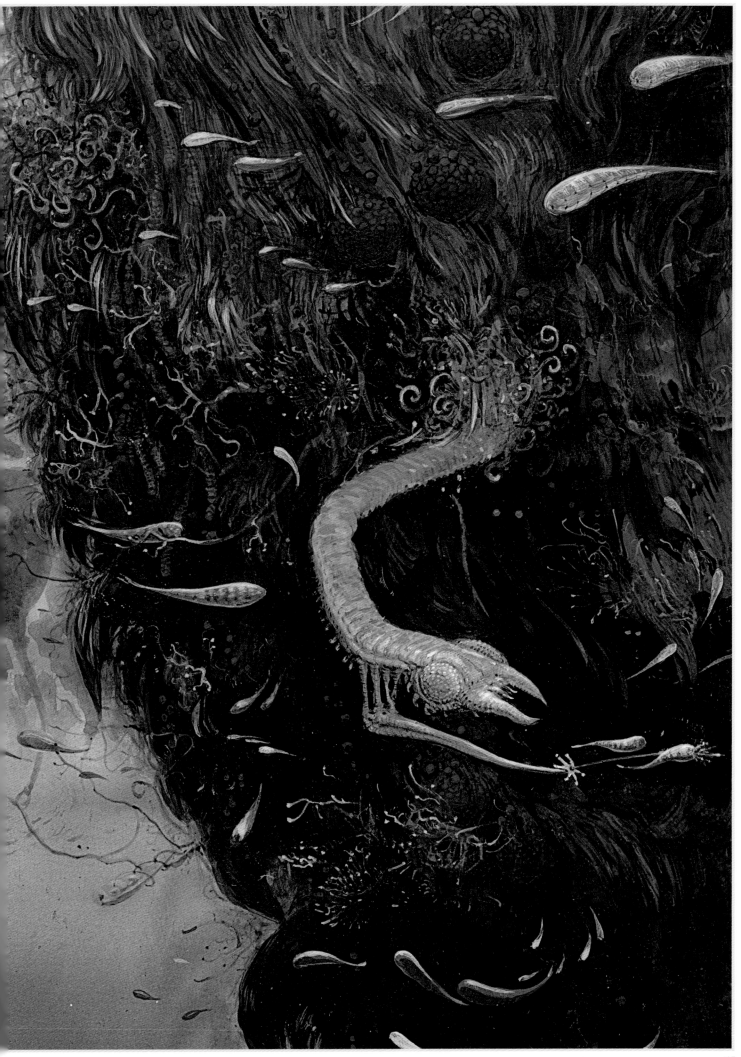

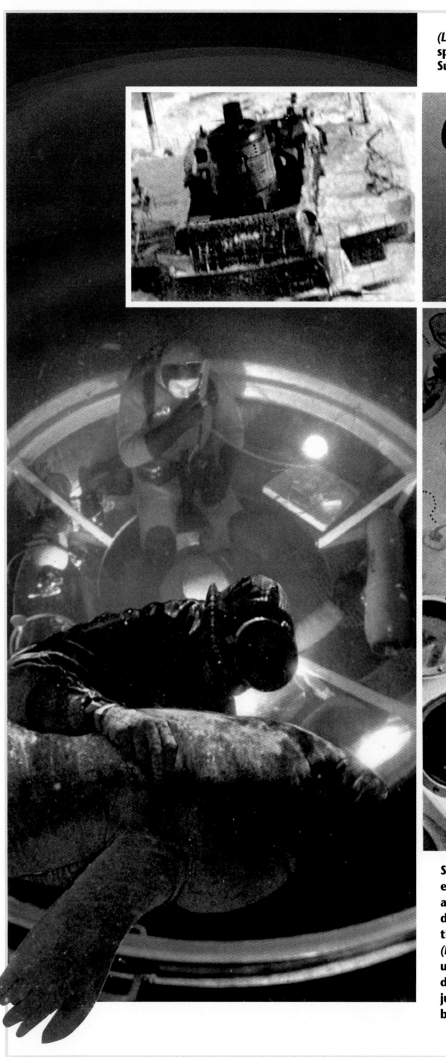

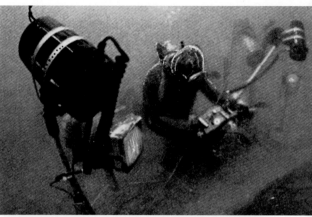

(Left) *Cousteau II* floats in a gale while *(below)* divers ri[g] special sensors to penetrate algae-fogged methane. Suit bubbles are not air but vented flotation gas.

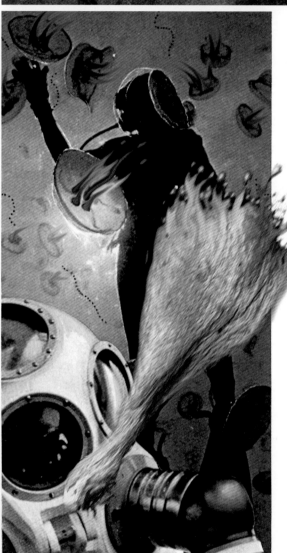

Swimming free in methane was a life-changing experience for Feris Delosi, seen *(above)* encounterin[g] a school of jellyfish-like animals. Below him anothe[r] diver in a Polycer Deepsuit prepares to descend to the meth-ice-covered sea floor a half-mile below.
(Left) "It cost me a hand, but I touched him," says th[e] unrepentant Feris of the moment caught by anothe[r] diver's camera. "The creature swam toward me and just yanked off my glove. I felt a leathery softness before my hand went numb."

"Diving in methane was not our goal," writes Cousteau, commander of Starship *Calypso*, "but to understand life so different from our own. We came equipped to explore as completely as possible. *Calypso* launched *Cousteau I* and *II*, then remained in orbit for the entire mission monitoring our movements and weather changes. We were a three-part team of 22 people, six in space and eight on each surface ship.

"On Winsor we worked about 10km apart, monitoring each other while performing separate tasks, to gather as much data as possible during our year there. We knew that the surface is often torn by violent storms, but the actual experience of one was beyond our imaginations. They sweep the seas with winds of 400kph or more, pulverizing animals who hug the surface for the sun's energy. These animals float with hydrogen in their systems and are generally fragile, looking similar to simple Earthly forms like jellyfish. Methane is lighter than water. When frozen it sinks. For us to swim in methane meant using special insulated suits that use helium for flotation.

"During our ocean survey *Cousteau II* was caught in a storm and observed its fury, while a sister ship flew above monitoring her progress. We all sat strapped to our seats and watched the monitors. Outside our bobbing, twisting ship was a world torn to pieces by flying methane crystals – a frozen universe of shattered creatures. After that experience we all elected to avoid storms. The planet's ecosystem, however, takes the destruction in stride. The storms chew up the ecology and distribute it to feed new life. Some animals we found absorb nutrients dissolved in methane directly through their skins.

"We found the few land areas barren and ravaged by tides that often sweep many kilometers inland, leaving vast areas of debris and erosion. The shore is sharp rock and blunted meth-ice stained with algae. Beyond the shores lies a silent frozen world of lofty white mountains standing like ghosts on the horizon watching the sea.

"But it was, after all, in the seas far from land that we found our kinship with this cold world. There, islands of life form from the floating debris, then grow again into reef-like community centers for creatures that drift and swim in the sun."

Thankfully, the mission was accomplished with no loss of life and many samples were gathered and returned to Earth for study at the Myhr Zoological Gardens. There they take center stage at the new "Alien Worlds" exhibit. ◆

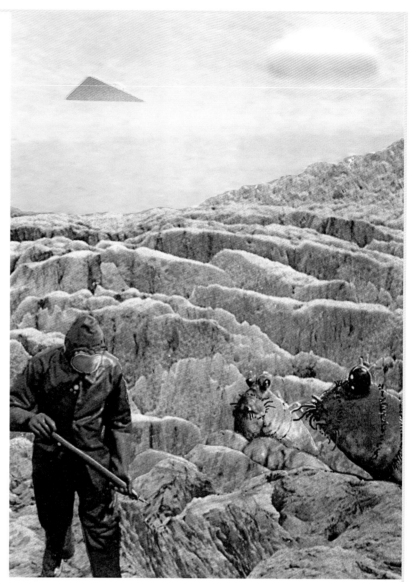

(Top) Galactic Geographic **exo-geologist Kem Westaede, armed with only an ice corer, steps briskly off an algae-stained meth-ice flow after the sudden arrival of scavenging "ice frogs," the only known land dwellers on the planet.**

(Above) **Watching a turbulent world below,** *Calypso* **waits in orbit for the return of her crew. Named for 20th-century founder Jacques Cousteau's ship, the modern** *Calypso* **carries on the long tradition of helping overburdened scientific institutions investigate life in the seas of Earth or any other world.**

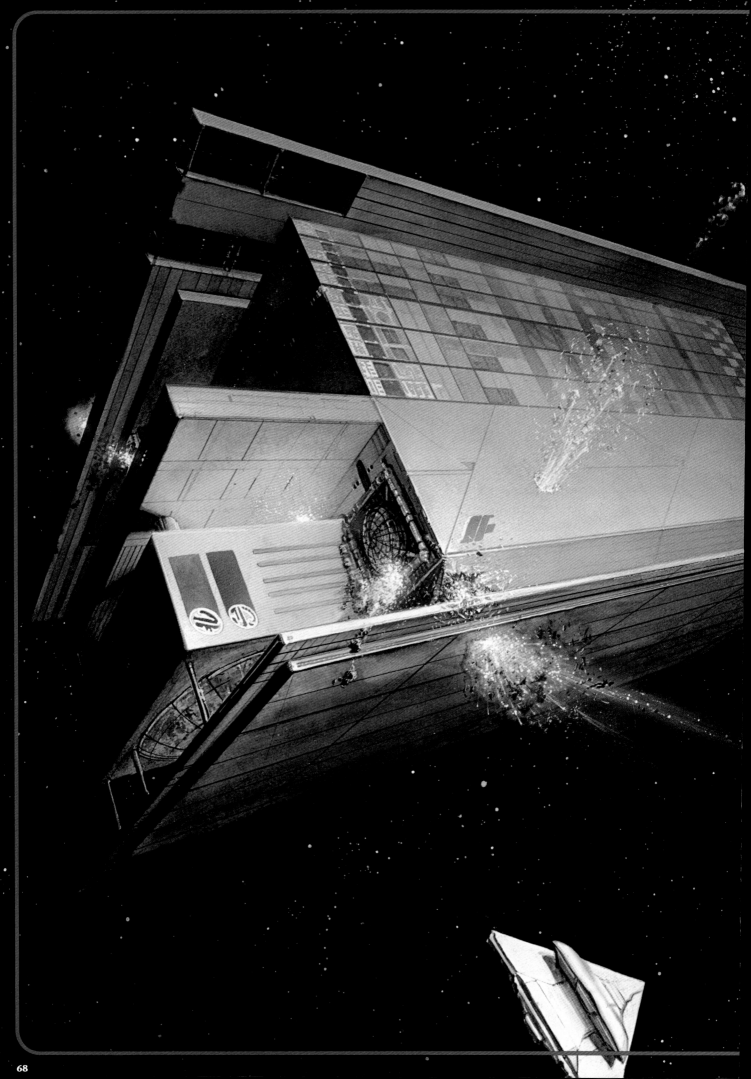

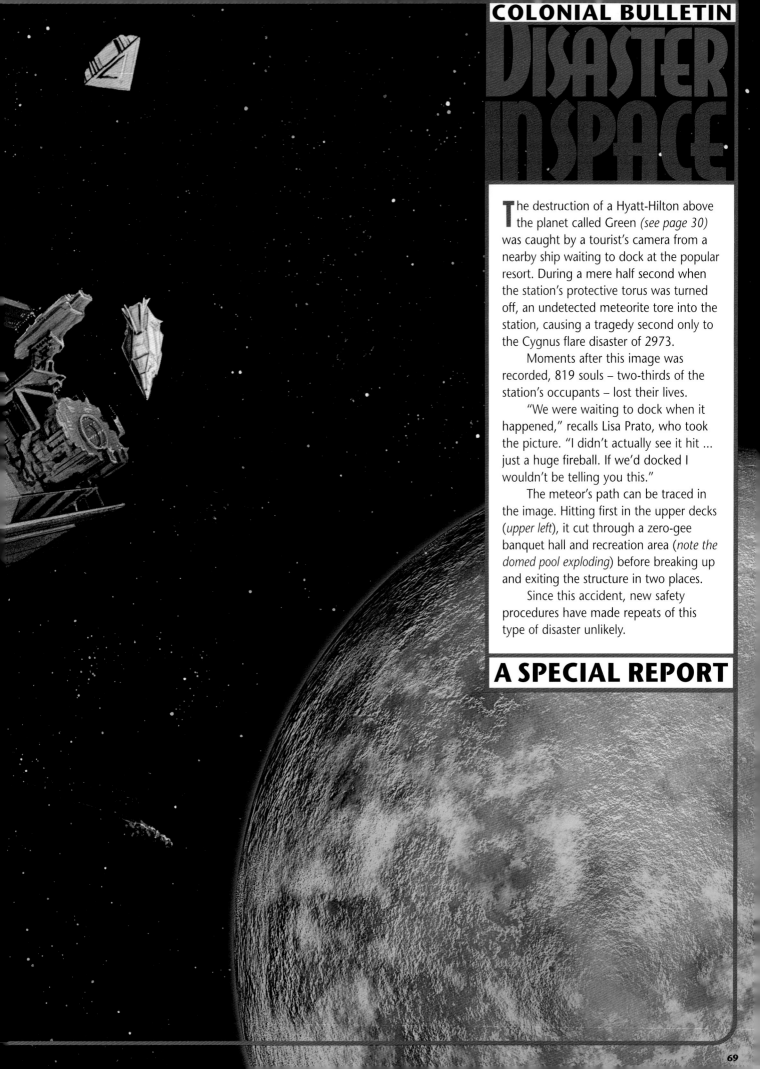

DISASTER IN SPACE

The destruction of a Hyatt-Hilton above the planet called Green *(see page 30)* was caught by a tourist's camera from a nearby ship waiting to dock at the popular resort. During a mere half second when the station's protective torus was turned off, an undetected meteorite tore into the station, causing a tragedy second only to the Cygnus flare disaster of 2973.

Moments after this image was recorded, 819 souls – two-thirds of the station's occupants – lost their lives.

"We were waiting to dock when it happened," recalls Lisa Prato, who took the picture. "I didn't actually see it hit ... just a huge fireball. If we'd docked I wouldn't be telling you this."

The meteor's path can be traced in the image. Hitting first in the upper decks (*upper left*), it cut through a zero-gee banquet hall and recreation area (*note the domed pool exploding*) before breaking up and exiting the structure in two places.

Since this accident, new safety procedures have made repeats of this type of disaster unlikely.

A SPECIAL REPORT

How Federation members use asteroids as raw materials for construction in space

"Asteroids are the latchkeys to the stars!" remarks starship designer and astro-engineer Daniel Hoy, of the Federation Starship Construction Yard 4, orbiting the water world and principal Human colony Planis. Indeed, asteroids of various types provide raw materials used in building starships and in sustaining the orbiting stations that build them. "Everything from water to gold is locked inside them," adds Hoy. "The material has been there for billions of years, just waiting to be used. The trick is getting to it, and then fabricating it into usable vehicles."

ASTROMINING

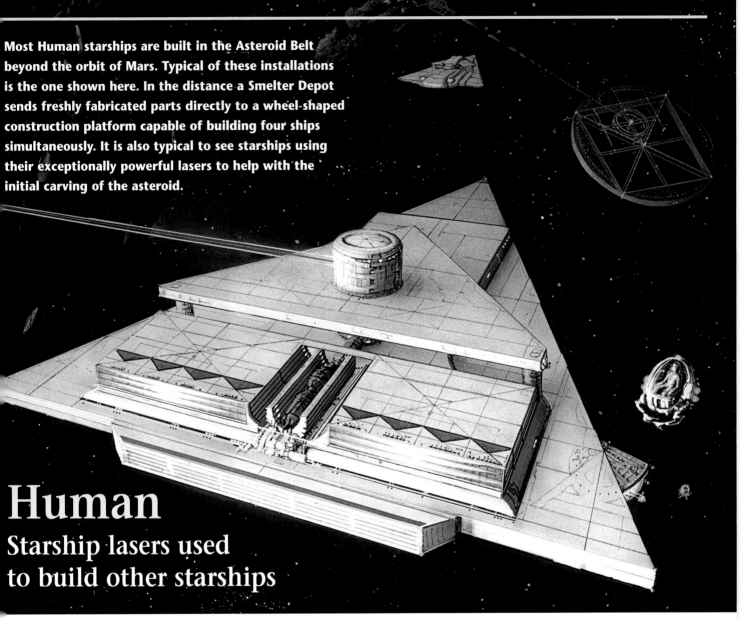

Most Human starships are built in the Asteroid Belt beyond the orbit of Mars. Typical of these installations is the one shown here. In the distance a Smelter Depot sends freshly fabricated parts directly to a wheel-shaped construction platform capable of building four ships simultaneously. It is also typical to see starships using their exceptionally powerful lasers to help with the initial carving of the asteroid.

Human
Starship lasers used to build other starships

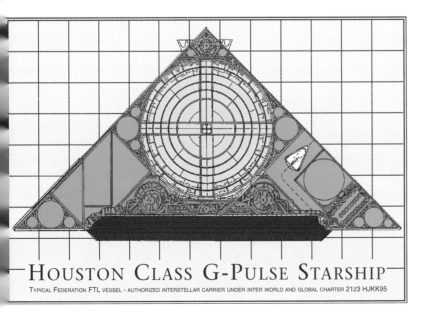

HOUSTON CLASS G-PULSE STARSHIP

TYPICAL FEDERATION FTL VESSEL - AUTHORIZED INTERSTELLAR CARRIER UNDER INTER WORLD AND GLOBAL CHARTER 21z3 HJKK95

*T*he G-Pulse starship has been called humanity's key to the cosmos. Constructed primarily from astromined materials, it has a simple design housing a spinning, gravity-producing crew section (*yellow in the diagram at left*). Powering the vessel are two fusion accelerators (*green*) that drive a G-Pulse neutronium "wedger" (*red*), which catapults the starship through space inside a gravity wave, bypassing the physical limits of normal spacetime. Traveling many times faster than light, each ship has the power potential of a miniature sun. Cargo space (*blue*) and a shuttle (*white*) account for the rest of the ship's interior. The vessel in the image above represents a typical Exploration Class starship. Other configurations add decks and thickness, but are fundamentally the same.

Tsailerol

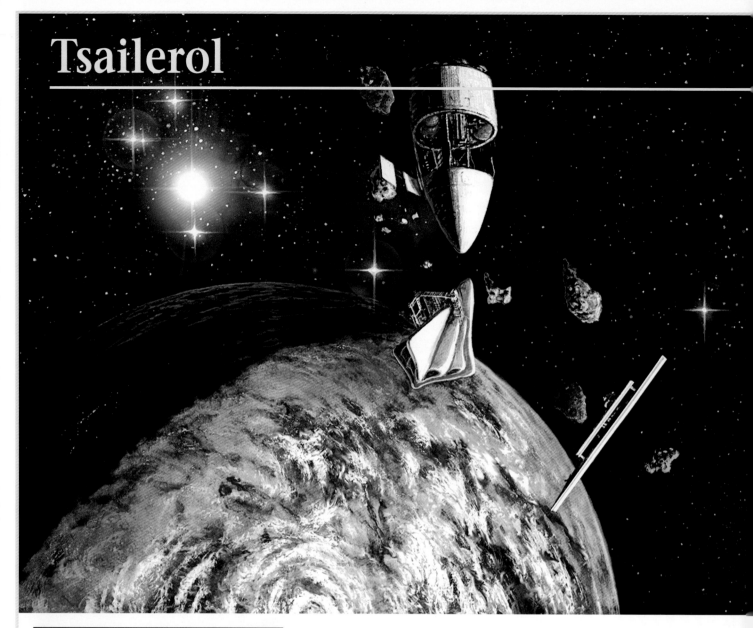

*F*irst of the non-Human Federation members are the Tsailerol. Their deep-space starships are hewn from hollowed asteroids, as shown on the opposite page. Above we see an astromining station framed by the Pleiades star cluster and the Tsai home world and moon.

Discovered over a hundred years ago by the starship captain who gave the new species their name, the Tsai became a test case for the Federation's Human/alien policies, one that proved successful, judging from the opinions of the four thousand Human colonists now living on the Tsailerol home world.

At left is a facsimile of the document that codified the pact between our divergent cultures. The document is held at Earth's Lunar Museum. It displays one of many similarities between Humans and the Tsai: writing. That is not to say, however, that Earth/Tsai communications are easy. Colonists report that misunderstandings can arise because of the Tsai's extremely materialistic view, which was noted as soon as linguistic dialogue was established. The colonists were curious as to why the hollowed asteroids were painted in bright colors. The answer: "So they won't look like asteroids." This anecdote led to a joke among Human colonists: Why are the Tsailerol blue? So they won't look like asteroids. But most colonists take their work with the Tsai as no joking matter. "As they are the primary non-Human members of our Federation, it is important that our relationship develop in a smooth, cooperative manner," says the administrator of the first Human settlement on the Tsai home world.

Carving asteroids into starships, from the inside out

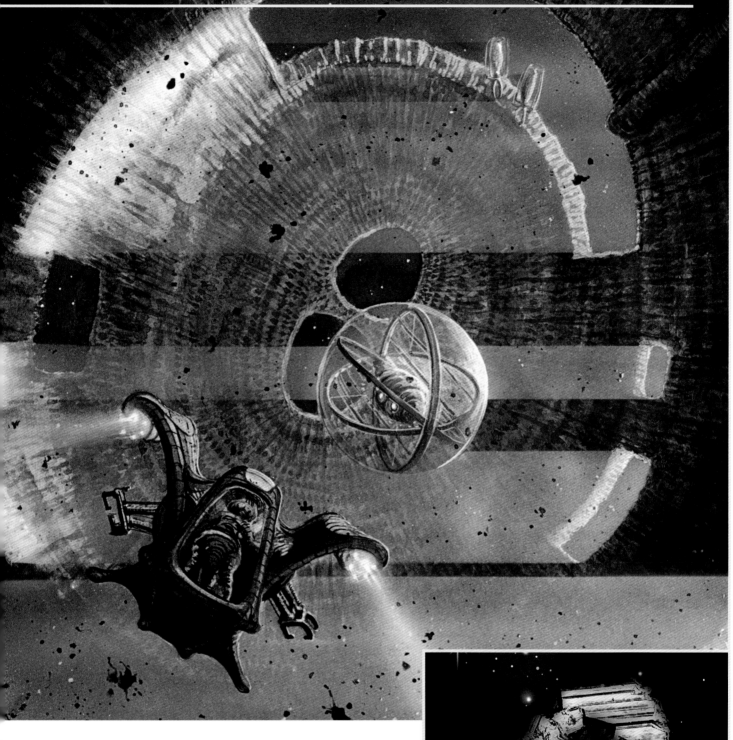

The Tsailerol use hollowed asteroids to make their starships. In the image above, an asteroid is undergoing such a transformation. Construction is accomplished using a powerful photon lathe to vaporize the interior of the asteroid. Some of this debris is collected and used to build the interior of the ship. Because of the volume of loose debris produced in the process, the lathing is always done far from the Tsai home world so the material can't enter the planet's atmosphere and cause damage. After the process is completed, the interior is fitted with living and cargo chambers, fuel cells, and the unique Tsai hyperfusion drive system. A typical Tsai vessel is shown at right, newly assembled but minus its final coat of brightly colored sealant.

Noron

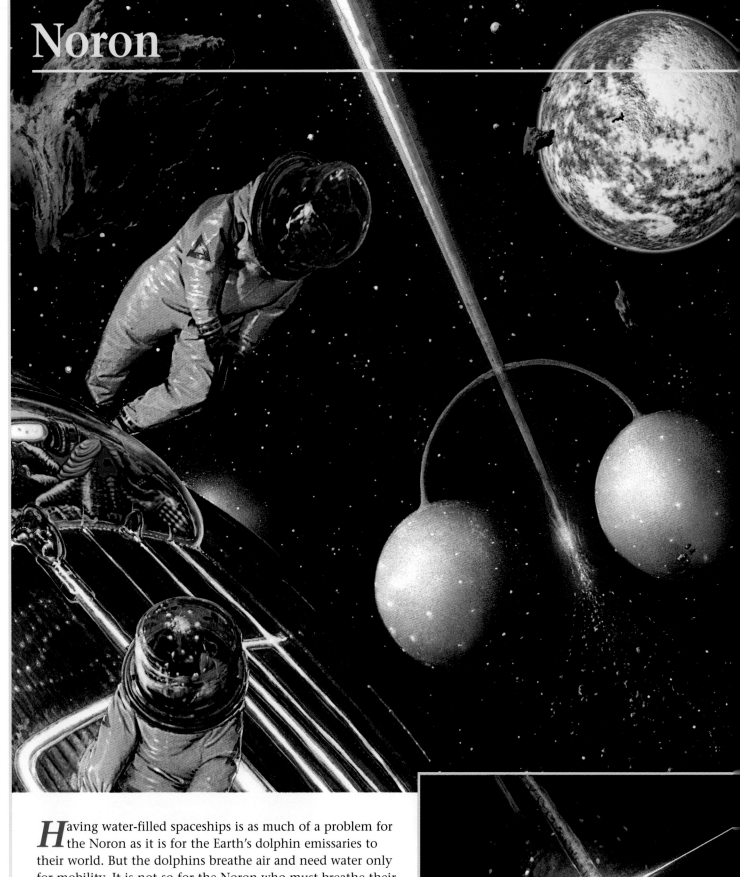

*H*aving water-filled spaceships is as much of a problem for the Noron as it is for the Earth's dolphin emissaries to their world. But the dolphins breathe air and need water only for mobility. It is not so for the Noron who must breathe their water to survive. In the scene shown above, a leaking Noron ship is receiving emergency repairs from a crew from another vessel. But there are advantages to water-filled vehicles. Leaks usually seal themselves in the cold of space. Weightlessness adds its own problems, so most large Noron vessels are constructed with one-way corridors of smoothly flowing water currents. Food and oxygen are distributed to their bodies via the water they breathe.

Spinning metal starships from asteroids

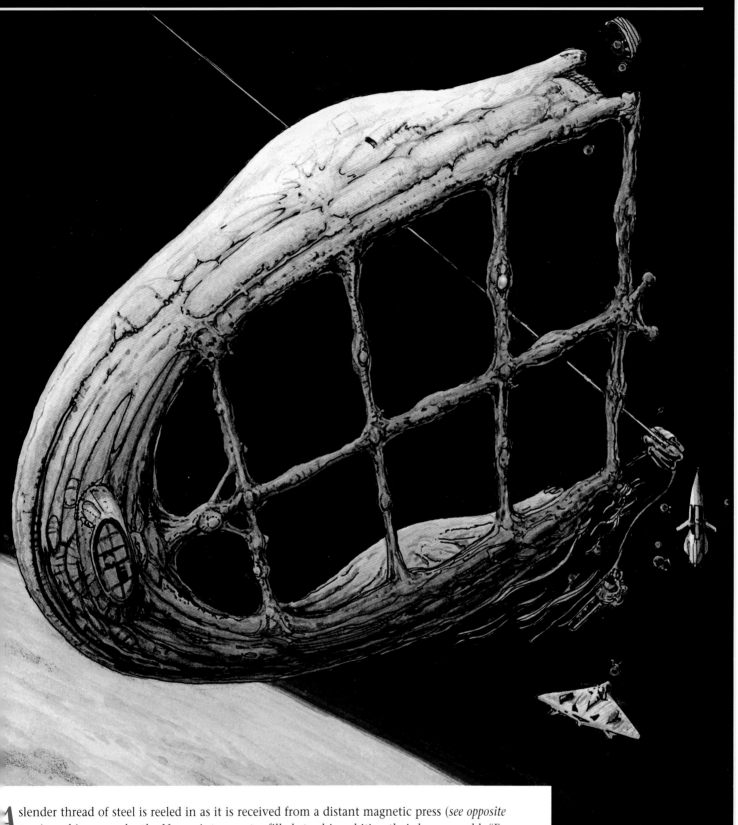

slender thread of steel is reeled in as it is received from a distant magnetic press (*see opposite page*), and is woven by the Noron into a water-filled starship orbiting their home world. "For a creature whose nearest Earthly counterpart is the lowly clam, the Noron do quite well," jokes xeno-biologist Sophia Prato, who is credited with having made first contact with the Noron. "After all, they can spin ships from ribbons of steel. They are sophisticated, clever, friendly, and not the least squeamish about Humans or Tsai working with them." But she adds with some frustration that years of studying the Noron "haven't given us any real understanding of how they think. Our dolphin crews know them best, but even to them the Noron are often a mystery. But we attribute this largely to physiology rather than temperament. I find the Noron endlessly fascinating."

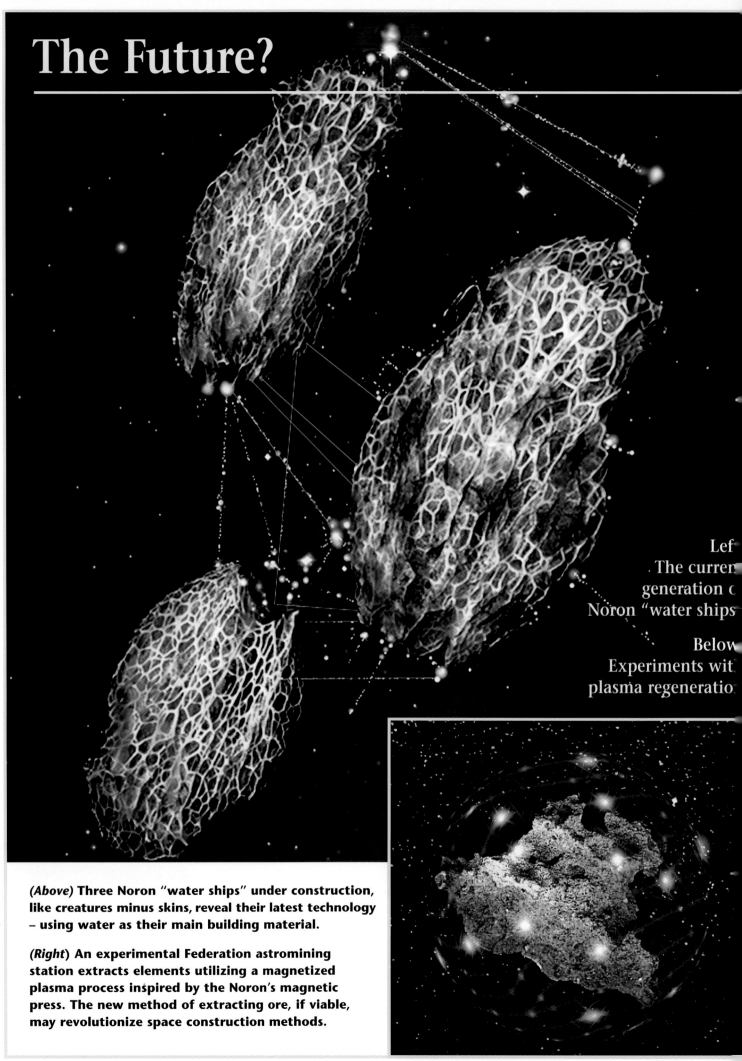

The Future?

Lef[t]
The curren[t]
generation o[f]
Noron "water ships[".]

Below[:]
Experiments wit[h]
plasma regeneratio[n]

(*Above*) Three Noron "water ships" under construction, like creatures minus skins, reveal their latest technology – using water as their main building material.

(*Right*) An experimental Federation astromining station extracts elements utilizing a magnetized plasma process inspired by the Noron's magnetic press. The new method of extracting ore, if viable, may revolutionize space construction methods.

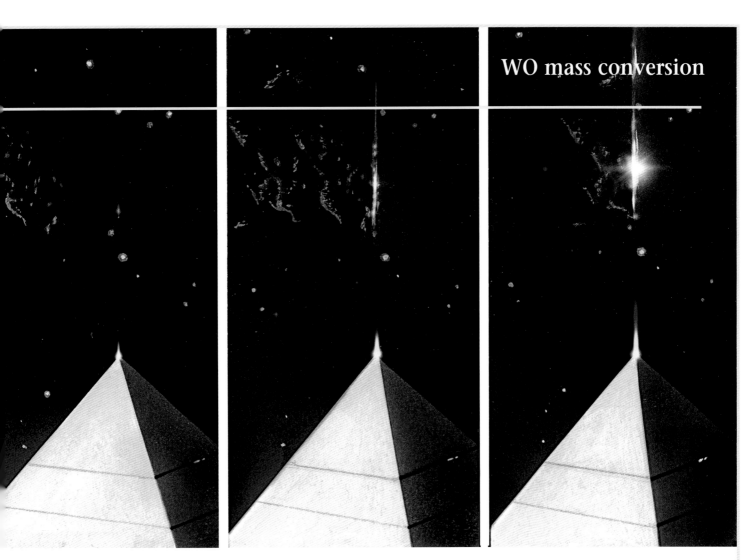

STARSHIPS OF THE FEDERATION

Federation Exploration Class FTL Starships
and their construction dates.

EARTH – 703 • Flagships – 10

Houston	2840
Goddard	2855
Galileo	2861
Kennedy	2920
Armstrong	2971
Gagarin	2985
Einstein	2986
Hawking	2990
Hubble	2999
Millennium	3001

TSAILEROL – 121 • Flagships – 5

At'Tma'

Drhu'Hmpa

Dn'Ghog'Vat

R'mag'Pojm

V'um'wl'Hva

NORON – (347*)

*The Noron do not name their ships
Numbers shown are estimates

As we have seen, astromining methods throughout the Federation of Worlds vary greatly. Yet the resource is the same – essential material extracted from asteroids or comets. It is estimated that in every planetary star system enough of this material is available to build at least two more planets like the Earth. Thus we seem to have an inexhaustible source of building materials available for any purpose.

No discussion of astromining would be complete without mentioning the WO, the supercivilization at the edge of Federation space. Theirs is an ancient civilization that once applied technology to space exploration, but is now applying it only to the preservation of their world. To this end, the WO have used every scrap of their system's extra material to build a shell (a Dyson Sphere) around their sun. It can absorb most of their star's energy for use in various tasks, including regulating their planet's weather.

The sequence above shows a pyramidal WO space ark dismantling an asteroid using a method beyond Federation expertise.

"These people are so far ahead of us," remarks WO technology expert Ned Bloom, "that we'll be studying them for centuries before we understand their techniques. If they let us, that is."

Bloom's team reports that the WO have a way to magnetically disintegrate matter and fabricate it in any form compatible with the material being used. For example, each of their hollow arks, with its many hundreds of levels inside, was built from an asteroid the size of Jupiter's moon Amalthea.

Such techniques are currently beyond Federation abilities, but many scientists believe that, as we colonize the galaxy, advanced space-fabrication methods, like those used by the WO, will become routine. Others are not so optimistic, at least about an open-ended expansion to the stars. "The WO have been everywhere," notes writer Karl Kofoed, "but look what they're up to. Maybe we should be thinking more about maintaining what we've got than moving to the stars. But it's safe to say that, whether we colonize the stars or rebuild a depleted Earth, astromining will get us there." ◆

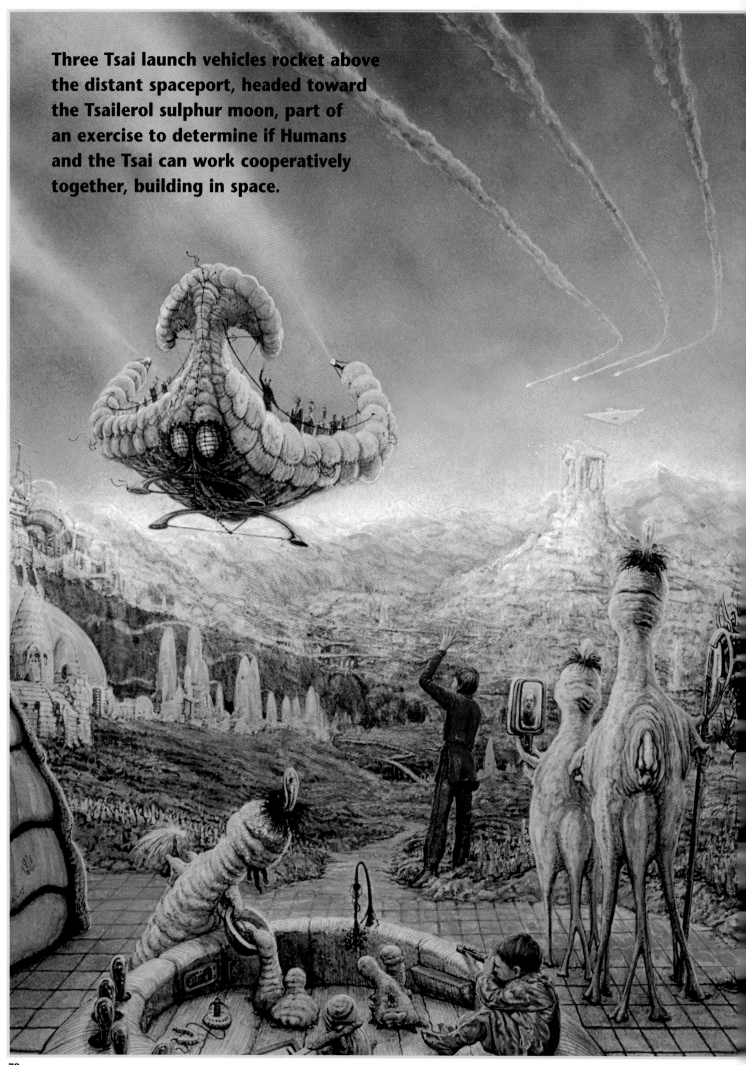

Three Tsai launch vehicles rocket above the distant spaceport, headed toward the Tsailerol sulphur moon, part of an exercise to determine if Humans and the Tsai can work cooperatively together, building in space.

At Home with the Tsailerol

Human colonists enjoy close contact with the Federation's closest allies.

"You won't find a closer match to the Human species than the Tsailerol," explains exobiologist Jan Pagh, one of the many Human colonists enjoying life among these blue, tripod-legged creatures.

The Tsailerol live on a world that some regard as a mirror of Earth. Certainly the Tsai themselves are physically closest to Human of any known extraterrestrial lifeform. They are carbon-based oxygen users who produce internal heat by metabolizing food. There, many argue, the similarities end. Others, like the colonists depicted on the opposite page, tell of many surprising similarities. In this image Human colonists are seen living in close harmony with the Tsai. Their culture is being studied with an emphasis on determining how evolutionary differences occur in species on worlds with a similar biochemical makeup.

Typical of the colonial scenes is the one shown here. Of particular interest is the pisp pen in the foreground, where young Tsai and a colonist's young son play in harmony. The woman, Jan Pagh, returns a wave from her husband who is standing on the rear deck of a typical Tsai transport vehicle, a steam-powered multi-chambered balloon. The man, whose face is seen in a young Tsailerol's magnifier, is bound for the spaceport in the distance, where a Federation starship readies for departure.

The boy is captivated by some distant object or by the spyglass relic he holds.

It is feeding time for the young Tsai, whose mother serves them up a protein-rich plant gel. The Tsai children are new to their tiny enclosure, which will be their home until they develop legs. Even at their young age, each has already undergone several transformations. They all started life as insect-like aquatic animals born of eggs strewn randomly in the marshes of this wet world.

The larval Tsai develop for at least a year. Then, in the Tsai equivalent of spring, they swim ashore and molt. At this stage their numbers dwindle drastically because they are left un-protected from the elements and from predation. Eventually the survivors are ritually selected and become "the chosen." They are the ones called children, like those shown here.

They spend all of their time in the pisp pen waiting for their final and most important transformation, the marriage of Tsai and pisp.

They will be rewarded with a tickle on the head if they behave properly and eat their dinner. The brush the mother uses mimics the sensation all Tsai greatly enjoy, the incessant tickling of the pisp's antennae, sniffing the breeze for danger. Their name comes from the sound pisps make when alarmed. "It sounds like a snake's nest sometimes if the pisps don't know you," observes Pagh.

Pisps are sensory surrogates, providing the Tsai the sense Humans call intuition. In reward for this service the pisp is carried permanently in its lookout position atop the Tsai's head, anchored to its nervous system, providing nerve stimulus while feeding off its host's copper-laced body fluids.

Tsai physiology, while closest to Human of any found so far, is both baffling and unique. Their coupling with the parasitic pisp has transformed the Tsai over millions of years, resulting in the civilization we see today. The link between Tsai and pisp is profound beyond this telling, and more of their strange culture will be explored in future issues.

The uniqueness of their physiology is of as keen an interest to colonists as their culture. They appear to be without eyes, but they actually have 360° vision provided by a wraparound eye membrane that is protected under a sheath of skin whose supple movements can, like a multiple pinhole camera, provide many views simultaneously. This kind of vision seems to work well for them when they run. Instead of a walking or galloping stride, they whirl like off-kilter tops, spinning their way across fields or down roads. This unique mode of travel is dubbed "dervishing" by Human colonists.

But, strange as these features may seem, the colonists also report many familiarities in the Tsailerol lifestyle.

As different as they are, the Tsai are peaceful folk. With the minority of their citizens involved in spacefaring technology, most Tsailerol are farmers, who routinely use their gardens to feed their families. Even the Tsai who crew starships garden when they can.

In the picture you can see that the sire of a Tsai clan, an elder whose random seed now plays happily with a Human child in his family's pisp pen, has safely rid the melon patch of a dangerous crab-like pest.

Like many Humans on Earth, this father-of-five gardens on the weekends. Here with his family, whose name is untranslatable, he is enjoying the simple pleasures of life as host, father, and gardener. ◆

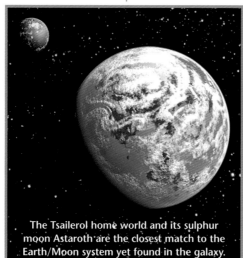

The Tsailerol home world and its sulphur moon Astaroth are the closest match to the Earth/Moon system yet found in the galaxy.

A MEETING OF CIVILIZATIONS

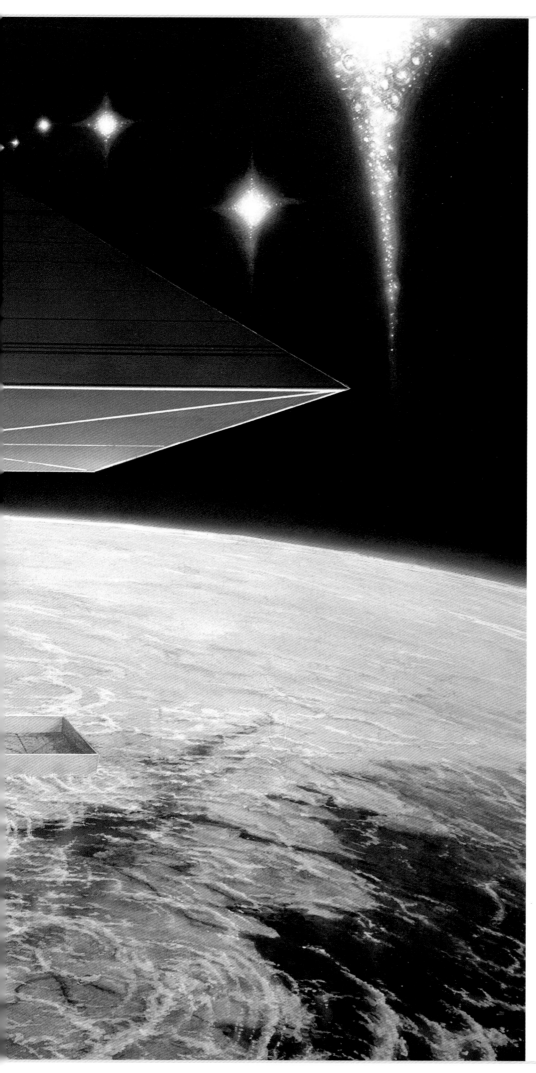

Poised above a planet bathed in noonday sun, a WO ark the size of a small moon awaits a first encounter with the Federation fleet in this view from the bridge of the starship *Garcia*.

Our delegation is awaiting the arrival of slower Noron vessels, still hours away. The excitement is palpable as we anticipate meeting an alien civilization.

For weeks we have been monitoring friendly WO transmissions and taking a crash course on the WO civilization and technology. Nothing, however, could have prepared us for this scene. (The name "WO" comes from the reaction of the *Garcia's* captain when he saw the giant pyramidal space ark that, we were told, was launched to serve as common ground for our meeting.)

The ark's launching bay, lying empty even of an atmosphere, can be seen on the planet's surface.

WO hospitality is evidenced by the string of starlike beacons that line our route to the landing bay inside the ark. We originally perceived the beacons as monitors or scanners, but our instruments did not confirm this.

Here, in this historic image, a newly discovered civilization, whose accomplishments include Dyson Sphere technology which harnesses the energy of their sun, openly awaits us with a graciousness almost as alien and unexpected as their wonder-filled world.

And so we come together for the first time: Human, Tsailerol, Noron and WO.

(continued)

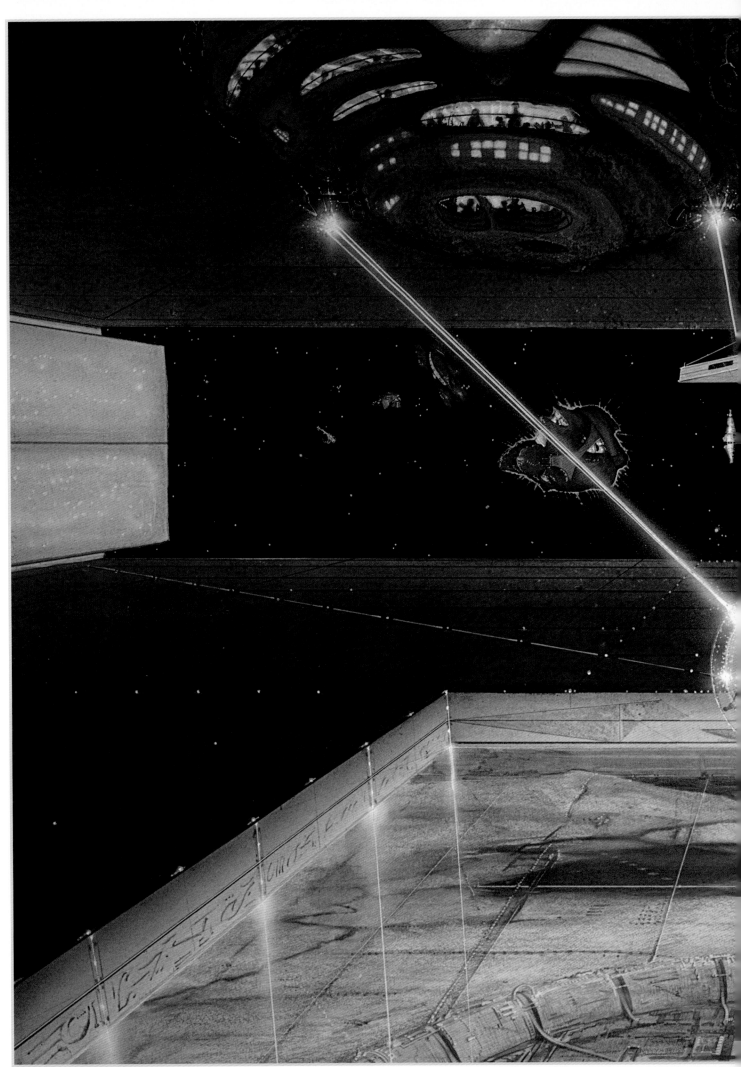

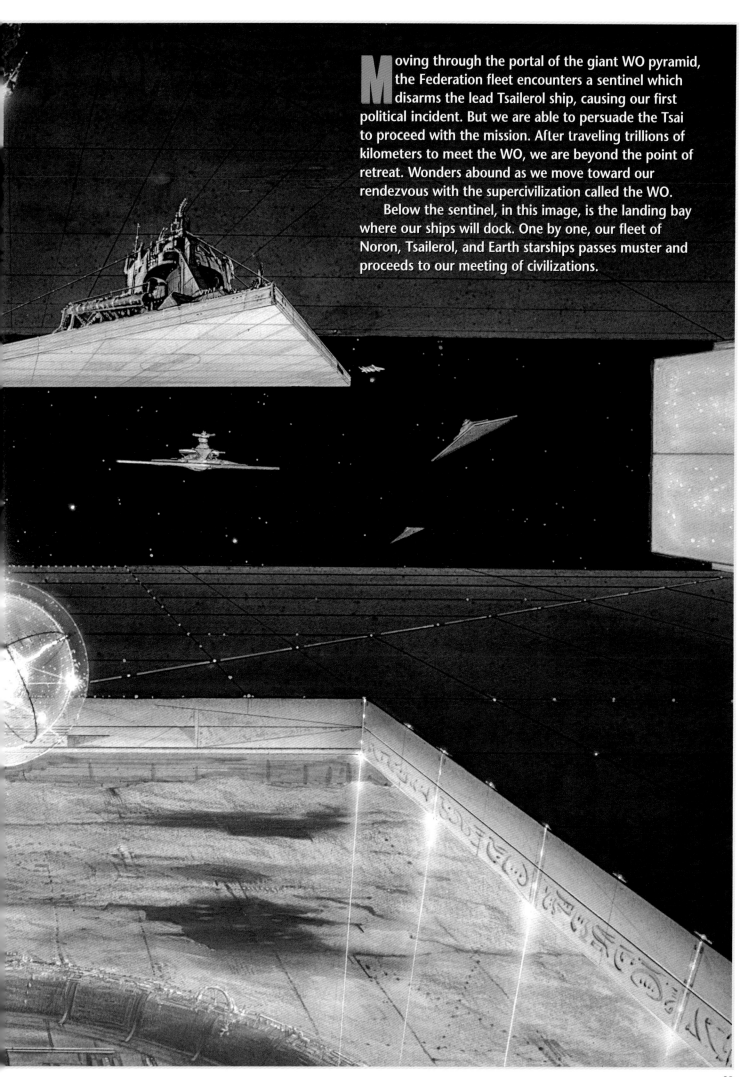

Moving through the portal of the giant WO pyramid, the Federation fleet encounters a sentinel which disarms the lead Tsailerol ship, causing our first political incident. But we are able to persuade the Tsai to proceed with the mission. After traveling trillions of kilometers to meet the WO, we are beyond the point of retreat. Wonders abound as we move toward our rendezvous with the supercivilization called the WO.

Below the sentinel, in this image, is the landing bay where our ships will dock. One by one, our fleet of Noron, Tsailerol, and Earth starships passes muster and proceeds to our meeting of civilizations.

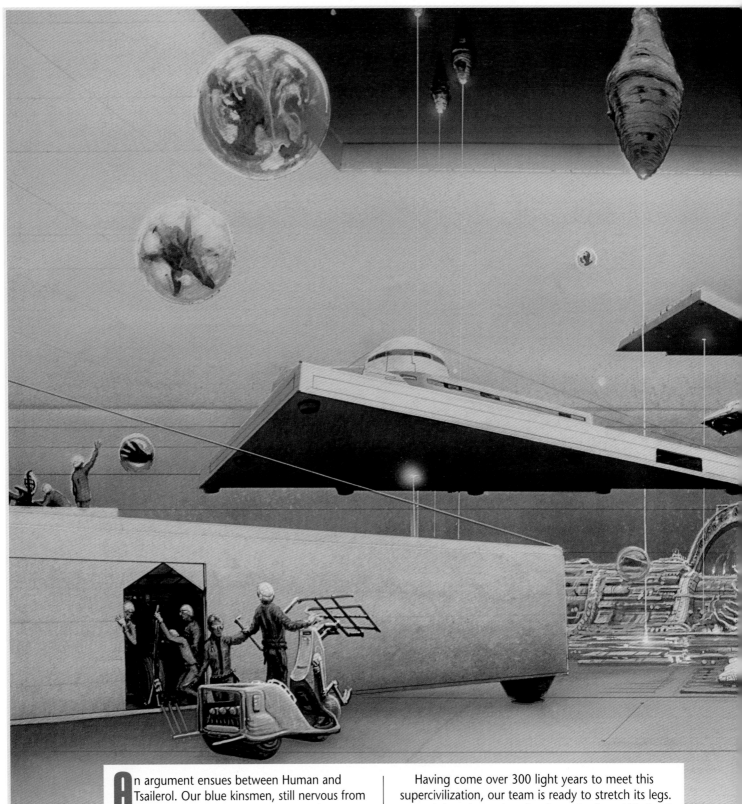

An argument ensues between Human and Tsailerol. Our blue kinsmen, still nervous from their incident at the pyramid's portal, are reluctant to leave their ship. Meanwhile, the rest of the Federation fleet disembark to begin exploring the WO vessel's labyrinthine interior.

Note the spheres hovering about our ships. Our biologists have identified these as Native Biological Entities (NBEs). One can be seen above, near the prow of the ship, imitating the shape of a Human hand. This is our first contact, face to face, with the WO civilization.

Having come over 300 light years to meet this supercivilization, our team is ready to stretch its legs.

And there is much to be done. Earth and Tsailerol ships are still landing, and the slower aquatic Noron ships have yet to be guided to their landing berths by WO beacons.

With their weapons disarmed at the WO pyramid's doorstep, the Tsai are understandably cautious. But a portable translation device solves the dispute and the Tsai soon agree to continue the mission. Such difficulties are common during joint explorational ventures, but crewmen take them in stride.

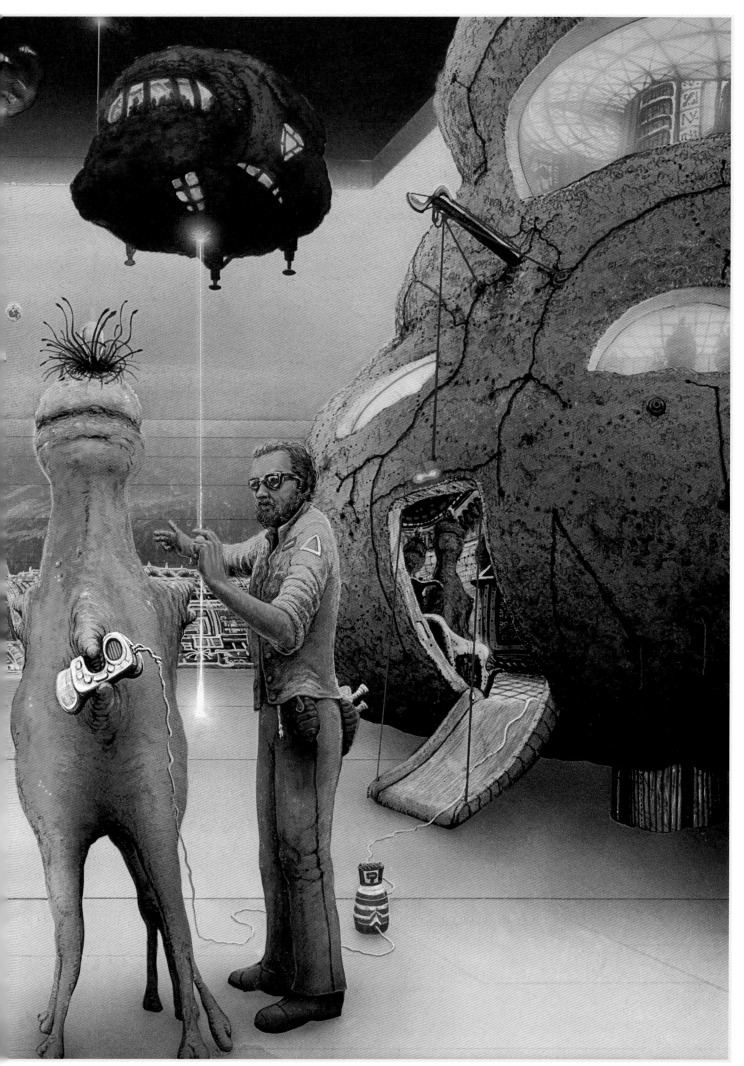

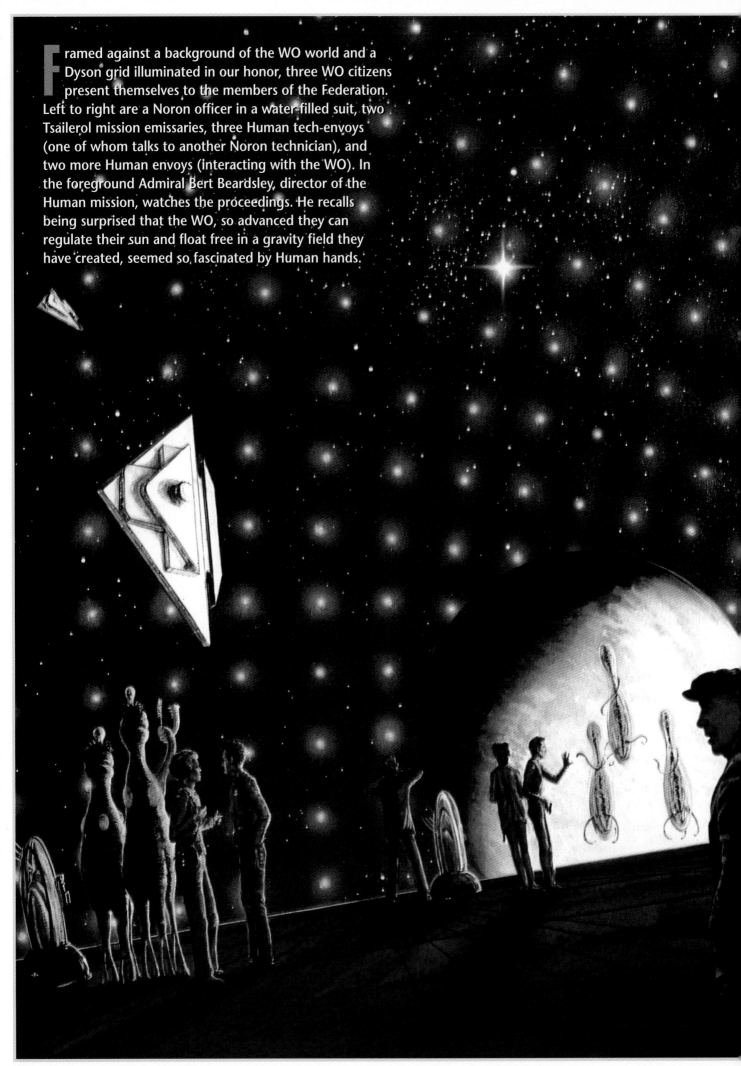

Framed against a background of the WO world and a Dyson grid illuminated in our honor, three WO citizens present themselves to the members of the Federation. Left to right are a Noron officer in a water-filled suit, two Tsäilerol mission emissaries, three Human tech-envoys (one of whom talks to another Noron technician), and two more Human envoys (interacting with the WO). In the foreground Admiral Bert Beardsley, director of the Human mission, watches the proceedings. He recalls being surprised that the WO, so advanced they can regulate their sun and float free in a gravity field they have created, seemed so fascinated by Human hands.

A scout craft leaves the *Garcia* to begin exploring the planet's surface. In the background, twin space arks frame a single icy moon. At the base of the ark on the right is a structure that we were told is a relic of an early space elevator.

Seeing the great pyramid of the WO floating in space was an amazing sight, but we were even more astonished to see it land in its docking bay. Except for the scale of the operation, the process seemed relatively simple.

First, four great walls rose in unison from the planet's interior. After they had lifted into position, isolating the docking bay from the planet's atmosphere, the air was pumped out of the space, and the pyramid, guided by forces unknown, settled neatly into the docking bay.

We learned that the WO use air pressure to assist in launching spacecraft from a central column in the pyramid. The spacecraft it launches are large rotating cylinders that are sent on one-way missions.

We were told that such launches are rare today, but were common thousands of years ago during the exploration phase of the WO civilization's development.

Our First Contact group, twelve scientists specially trained to work with unknown races, had been studying the WO long before we arrived at their system.

From transmissions sent by the WO we learned that they have records of each Federation race, and that Earth itself was visited in the past but the ill-fated cylinder crashed into the Earth. Our historians speculate that this may refer to the famous Siberian Tunguska explosion of 1908, which has always been assumed to have been caused by an asteroid impacting the Earth's atmosphere.

Apparently that exploratory mission was their last. It appears that they now concentrate their spacefaring efforts on matters relating to maintaining their star system and their home planet.

From everything we had learned the WO seemed to welcome our arrival. But appearances can often deceive, as we found when the Tsai refused to disengage their weapons systems as our group passed through the force field that served as a portal to the WO space ark.

Although there were no other incidents, many in our group – particularly the pragmatic Tsailerol – remained distrustful of the WO.

Despite our trepidation, our group unanimously elected to continue the mission. We spent several days exploring the many levels of the pyramid before descending with it to the planet's surface.

(continued)

After a week among the WO, our team is still overwhelmed by the two gigantic space arks. Exploring just one of them is like exploring an entire planet. Indeed, each contains a microcosm of the WO home world. Different levels contain marshes, farmland, deserts and seas. The pyramids cover an area 50km square and rise 400km above the planet's surface.

Looking down at a WO ark from space, we see clouds, rivers, and vegetation suggestive of an Earth-like environment. Cloudy updrafts at the pyramid's edges are the only visible effect the structure has on the atmosphere.

Karl Kofoed, aboard Earth ship *Garcia*, described in his notes the ark's landing: "As the ark moved toward the planet, four walls rose, forming a box-like landing bay. The ark settled into it and lowered to the surface. Then the walls retracted back into the planet. The operation lasted only a few hours and didn't seem to disrupt the atmosphere at all."

We learned that the WO pyramids were built around an atmospherically driven system for launching early space probes. Kofoed's notes contain a diagram of the system *(reproduced below)*. "It is as simple a launching mechanism as it is large," he wrote. "A 1000-meter cylindrical spacecraft is lowered down a tube at the center of the pyramid, compressing the air beneath it. The air above the cylinder is then removed, leaving an airless pathway to space. At launch, the cylinders are simply released from their moorings and air pressure pushes them into space. Fusion bursts power the craft thereafter."

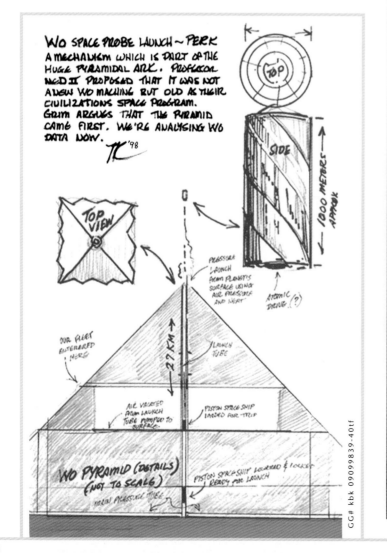

After spending much time examining the WO pyramid in space and after its landing, we are finally beginning our exploration of the planet itself. Our expedition members are a specially trained team with a wide range of scientific skills. They live in WO-approved base camps, each providing living space for a dozen Federation members. Land areas are explored by the Humans and Tsailerol, while the oceans are the aquatic Noron's specialty.

It comes as no surprise that the WO have learned to regulate life on their world. Its surface is dotted with areas that are left wild. The swampy wetlands, shown here in a sketch from a team-member's electronic notebook, are difficult to explore on foot. The land is a spongy bog populated by the WO equivalent of insects, worms and a curious creature called the bubblefly. The adult form was a constant problem for our team because their drift-and-snag feeding habits led them inevitably to become entangled in our gear. Not surprisingly, its life cycle has been well documented in countless notebooks. A curious later stage of the bubblefly's life cycle finds it living underground in a sac or pupa while its body changes into an adult. This is not a dormant phase in the creature's life. Its mouth remains above ground, snagging hapless prey (or shredding boots), as it grows. The field sketch by *Houston* crewman L.A. Thompson captures a mood cameras cannot; that is why expeditioners are encouraged to enhance their observational skills by taking time to make such sketches. Of her time in the WO wetlands, Thompson said: "It was a tough place to explore and field trips often got a little scary. The bubblefly is the worst. It gets snagged in our equipment, and as soon as the thing lands it starts eating."

Other areas of the planet are devoted to oceans, wetlands, forests, agriculture, and industry, each operated and cared for by citizens whose physical nature is complementary to those environs.

(continued)

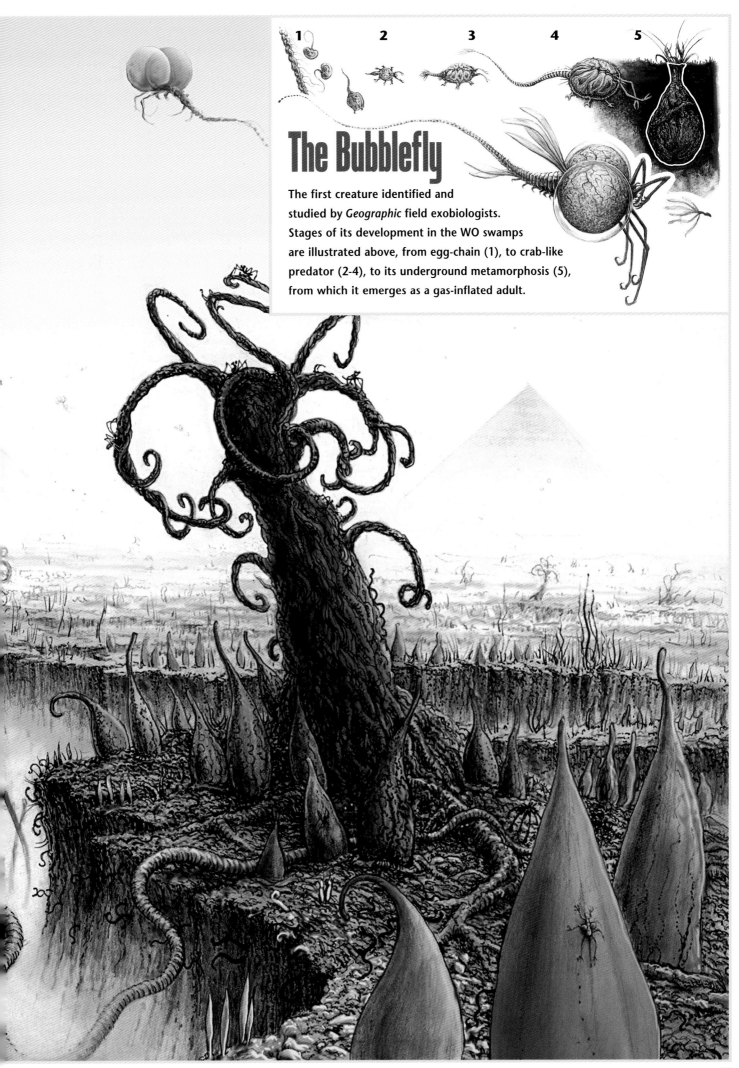

The Bubblefly

The first creature identified and studied by *Geographic* field exobiologists. Stages of its development in the WO swamps are illustrated above, from egg-chain (1), to crab-like predator (2-4), to its underground metamorphosis (5), from which it emerges as a gas-inflated adult.

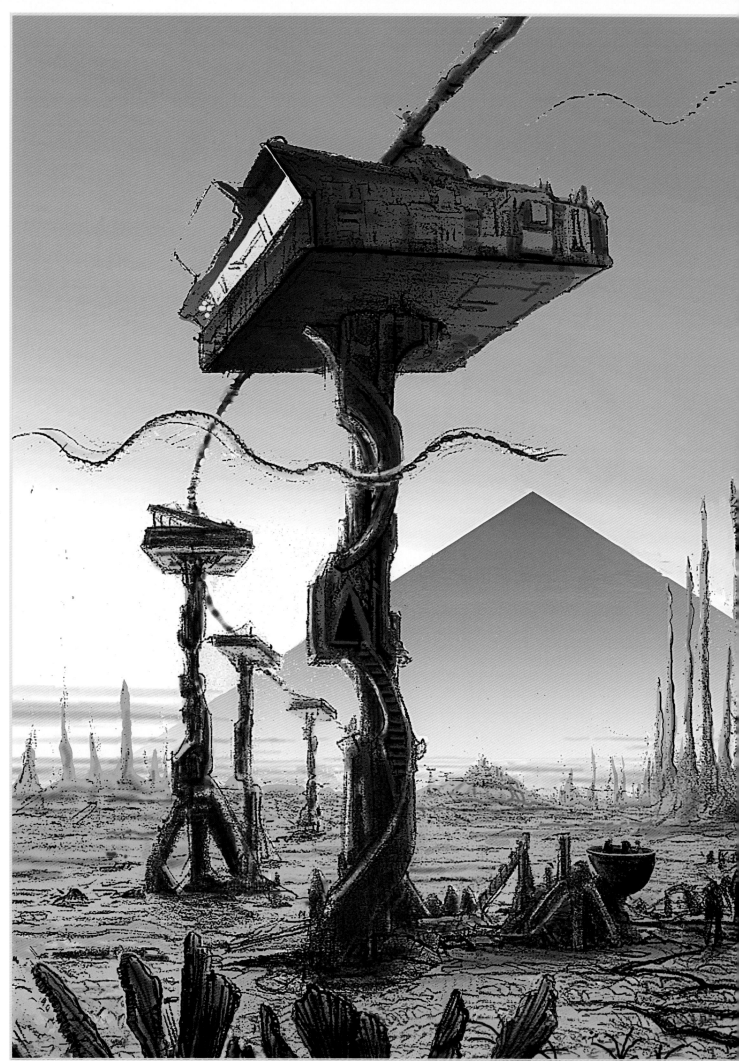

A great WO pyramid rises in the distance, providing a background to this DataStrator painting made by Karl Kofoed, one of the Federation's Human members assigned to explore the WO planet. He notes that the area represented is typical of the WO's populated wetlands.

This is the domain of the Worker WO, our name for the creatures responsible for the maintenance of the industrial and farm infrastructure of the WO world. We saw many types of these creatures. Because of their multi-legged and exoskeletal bodies, they were compared by Human researchers to Earth's insects. Here we see a Worker standing with a Human emissary from the visiting group near a structure that looks like a cross between a tramway and a tree house.

The structure is part of a complex conduit that channels energy across the surface of the planet. The structures also provide homes for the creatures who maintain the conduit and keep it functioning. The dwellings are built on tall pedestals to keep them high above the wetlands, which are flooded every year during the area's rainy season.

During that season – the equivalent of Earth's summer – seemingly dead trees (seen in a row at right and in the distance) are in full foliage and produce a black nut-like fruit that feeds the Workers. The nuts are harvested, then processed into a material that resembles a sticky black tar. The Workers' food is not ingested by mouth, but is placed directly into a pouch in the creature's midsection where it is digested.

The concept of eating seemed foreign to all the WO we encountered. Perhaps this is why they exhibited great curiosity about Human, Tsailerol and Noron eating habits and often gathered at our encampments at mealtimes.

What they think of our diverse and unique habits remains a mystery, since we have not yet established a language that allows direct communication. Our technicians have, however, received and interpreted a vast library of visual data, recorded since the WO civilization was discovered. *(continued)*

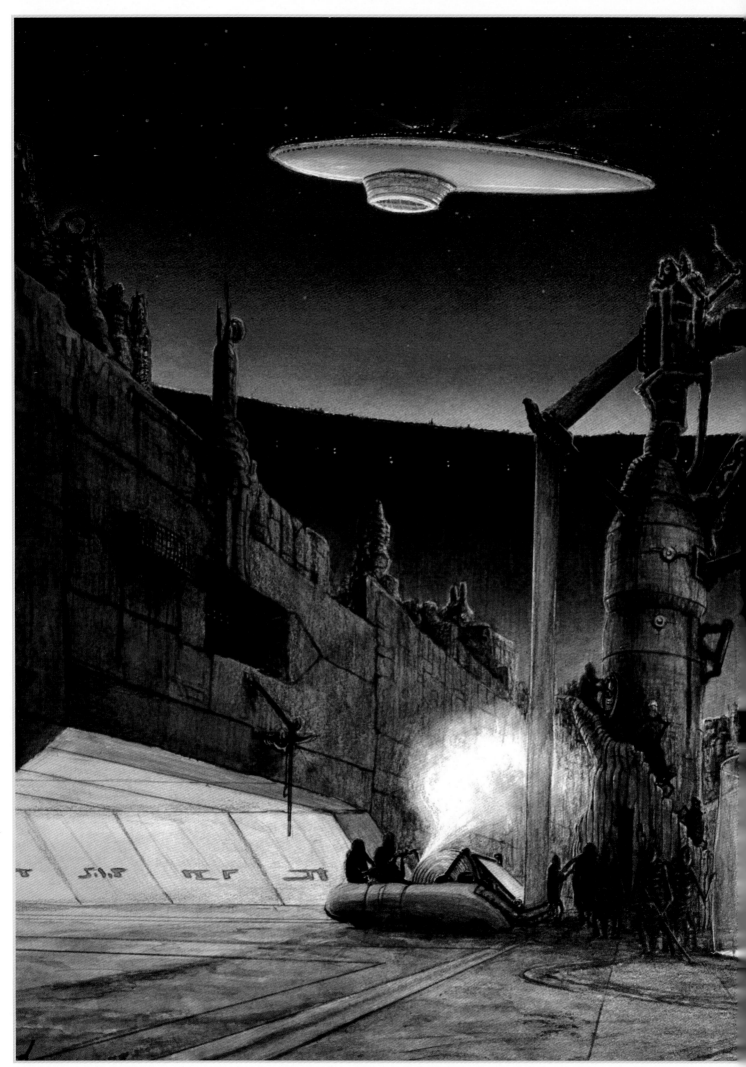

E xploration of the WO world continues to provide our people with material for years of study. We have spread out to examine the global disposition of the WO civilization and its impact upon the planet.

Our temporary colonists report their findings to Admiral Beardsley aboard the *Houston*, flagship of the Earth group. From there the report is sent to the Solar Quadrant, 300 light years away, by tachyon pulse. Despite our faster-than-light communications, transmissions between the WO system and home can take weeks, so we are essentially on our own.

The WO civilization is thought to be millions of years old. According to their records, they ceased space exploration long ago, instead turning their efforts to maintaining their world and its star.

Our teams found areas devoted to seas, wetlands, forests, farming and industrial zones, and an underground that is riddled by tunnels and even subterranean cities. We found each area populated by creatures whose physiology perfectly matches their environment.

Here we see the industrial zone, hewn thousands of years ago from bedrock. In the foreground, a group of Workers oversees the production of sheet metal extruded by a primitive machine that draws material from underground smelters. It is thought that geothermal energy drives the process. The sheet metal is then rolled, loaded onto small cars, and transported underground to fabrication centers.

In the background, a kilometer-high wall separates this area and the atmosphere above it from vast tracts of farmland that lie beyond *(see inset above)*, presumably so that industrial pollutants cannot migrate and contaminate agricultural products. Beyond the wall a large lighter-than-air ship of WO design prepares to touch down at a mooring station. We were told such ships are used to transport cargo and personnel. We saw many of these craft as we explored the planet. Each one seemed to travel without power, using the planet's prevailing winds for propulsion.

As nighttime descends, the industrial Workers will not stop working. Like Earth's ant colonies, they work continuously and rest comes through momentary pauses. Their efforts are equally divided between manufacturing and maintenance. This apparent hive-like lifestyle disturbed some of the Federation's Human observers, who likened the creatures' existence to slavery. Yet we saw no evidence of social discontinuity anywhere we visited. But we are careful not to form conclusions until we learn more about the WO.

(continued)

After a year studying them we are still wondering...

Who are the WO?

This historic image was humanity's first clue that a super-civilization existed at the fringes of known Federation space. Clearly visible is the WO Dyson Sphere — an artificial gridwork that forms an energy-absorbing shell around their sun. Because of this image a diplomatic armada, comprising Earth, Tsailerol and Noron ships, was launched to meet them.

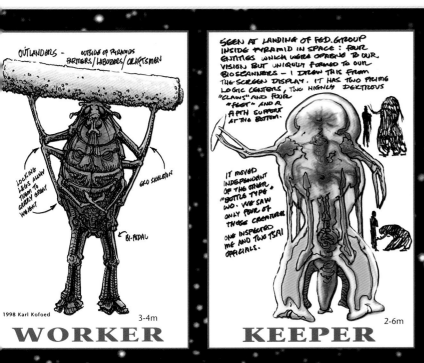

OUTLANDERS — OUTSIDE OF PYRAMIDS / FARMERS / LABORERS / CRAFTSMEN

LOCKING LEGS ALLOW THIGH TO CARRY GREAT WEIGHT

EXO SKELETON

BI-PEDAL

1998 Karl Kofoed

3-4m

WORKER

SEEN AT LANDING OF FED. GROUP INSIDE PYRAMID IN SPACE: FOUR ENTITIES WHICH WERE OPAQUE TO OUR VISION BUT UNIQUELY FORMED TO OUR BIOSCANNERS — I DREW THIS FROM THE SCREEN DISPLAY. IT HAS TWO PRIME LOGIC CENTERS, TWO HIGHLY DEXTROUS "CLAWS" AND FOUR "FEET" AND A FIFTH SUPPORT AT THE BOTTOM.

IT MOVED INDEPENDANT OF THE OTHER "BOTTLE TYPE" WO. WE SAW ONLY FOUR OF THESE CREATURES. ONE INSPECTED ME AND TWO TSAI OFFICIALS.

2-6m

KEEPER

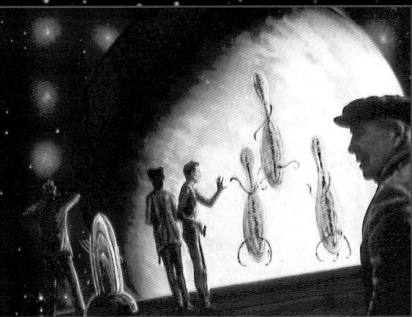

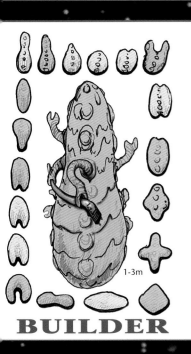

1-3m

BUILDER

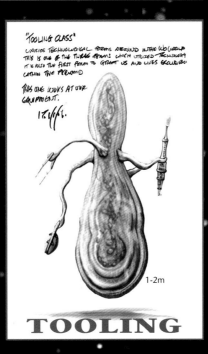

"TOOLING CLASS"
VARIOUS TECHNOLOGICAL FORMS ABOUND IN THE WO WORLD THIS IS ONE OF THE THREE FORMS WHICH UTILIZED TECHNOLOGY IT IS ALSO THE FIRST FORM TO GREET US AND LIVES EXCLUSIVELY WITHIN THE PYRAMID

THIS ONE LOOKS AT OUR EQUIPMENT.

K. Kofoed

1-2m

TOOLING

The WO civilization is the most advanced race in the known galaxy. Evidence of this is the sphere they have built around their sun. As flimsy as the shell may appear, it provides an amount of energy rivaling that used by all other technological races combined.

As our team concludes its mission and prepares for the 300-light-year trip back to Federation space, we ask ourselves, "Who are the WO?" Our best guess is that there are four distinct types, as represented here in four sketches made by team members.

We have seen the Workers *(top left)* in many guises on the surface of the planet. But the soft-bodied creatures shown here were seen only aboard their giant pyramidal space ark. These, we presumed, were the WO who hailed us from deep space, met us (and studied us) aboard their space ark, and kept appearing and disappearing as we explored its vast interior. We called them the Sentients.

The Builder and Tooling WO assumed any shape necessary for performing a given task. The sketch at bottom left shows the Builder's many physical permutations. The one we came to refer to as the Keeper *(top right)* was a soft-bodied creature with structural integrity. Despite its large size, the Keeper type WO was observed slipping through small holes in bulkheads and made frequent unexpected appearances before members of our party.

After an Earth year with the WO we are still perplexed by their mastery of multi-location antigravity systems and how they manage to channel energy and use it to regulate their star and their planet's weather. The Federation of Worlds is hoping the WO will share their secrets so that one day threatened ecologies can be transported to safety.

As Admiral Bert Beardsley concluded, "We lived with the WO, but we've come away with more questions than answers. Who are they? I'm sure the answers will come as long as good relations between the Federation of Worlds and the WO continue." ◆

Introducing the **UNIROVER** from

TerraTours

Your key to fun and adventure on this or any other world.

No other vehicle delivers the off-world reliability and performance of the **NEW UniRover** from TerraTours.

Now with Polycer shielding, the same material used to protect starships, it can explore any environment – from the ice lakes of Titan to the volcanic continents of Venus – in freedom and safety.

TerraTours vehicles come in a variety of sizes and configurations. From small family models like the one shown here to the more rugged Orion Series excursion models, you will find a TerraTours vehicle to suit all your family's needs.

NEW LOW RATES
INQUIRE DIRECT USING ADSCAN

▼

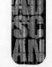

FOUND IN SPACE

ARTIFACTS AND CURIOS FROM THE UNKNOWN

Items of curiosity and wonder are showcased at a new exhibit in the great dome
of the Myhr Zoological Gardens, Earth. On these pages are samples from
the exhibit and the *Galactic Geographic* archives.

◆ FROM THE GALACTIC GEOGRAPHIC

Above: The BlueStone (54m × 73m × 38m) — Found 2890 orbiting a moon in the Planis system.
Origin unknown. Age unknown. Inscription undecipherable.

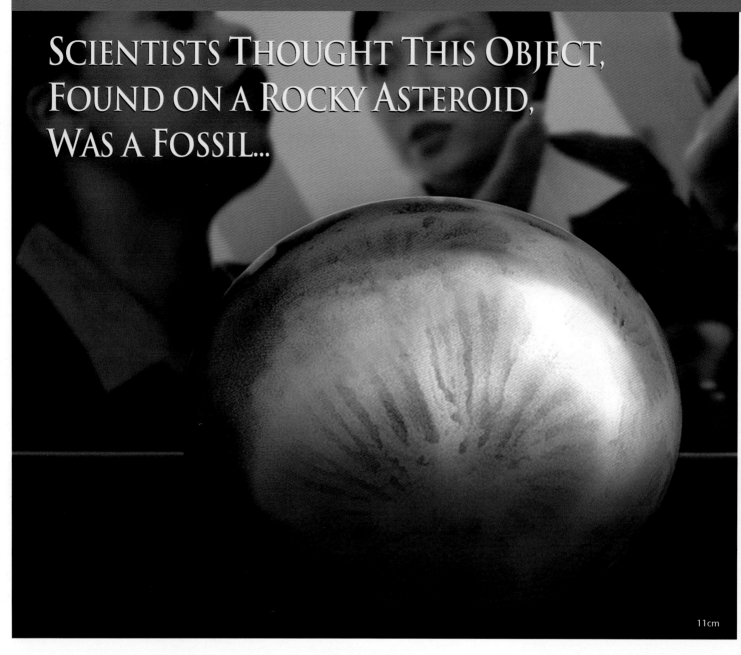

SCIENTISTS THOUGHT THIS OBJECT,
FOUND ON A ROCKY ASTEROID,
WAS A FOSSIL...

11cm

I n the Myhr Zoological Gardens Hall of the
Nova Stone a new museum exhibits mysterious
objects and lifeforms that were ...

FOUND IN
SPACE

Article by Galactic Geographer Karl Kofoed

O rganic or mineral? These egg-
like objects were thought to
be fossils when they were given
to the Federation's Planis labs for
evaluation. The finder, a curious Tsailerol
surveyor, said he'd seen many of them
littering the surface of an asteroid he was
surveying for use as a Tsai starship. He
collected two and placed them in a
quarantined locker.

The organic nature of the specimen
was revealed when it was exposed to heat
and water. Since then it has grown in
crystalline fashion, resembling a plant.
Its twin, the second egg *(inset right)*, has
shown no signs of life.

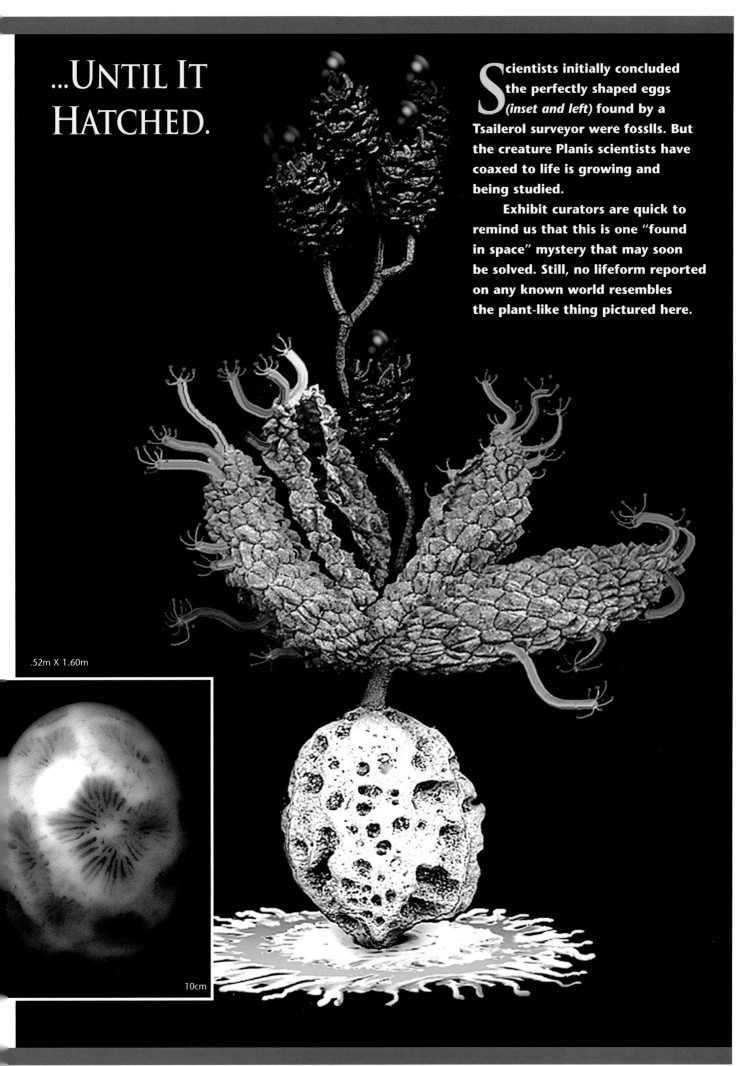

...UNTIL IT HATCHED.

Scientists initially concluded the perfectly shaped eggs *(inset and left)* found by a Tsailerol surveyor were fossils. But the creature Planis scientists have coaxed to life is growing and being studied.

Exhibit curators are quick to remind us that this is one "found in space" mystery that may soon be solved. Still, no lifeform reported on any known world resembles the plant-like thing pictured here.

.52m X 1.60m

10cm

PRATO PLANT...
THE FIRST
COSMIC WEED?

18cm x 53cm

Asteroids in many star systems have been the source of fascinating treasures and strange discoveries. One such oddity is the Prato Plant, discovered by, and named after, astrominer Paul Prato while he was working with a Tsailerol crew to establish a com link between their starships and our own FTL and SL cruisers.

The mysterious plant-like blossom grew from the colorful microscopic object shown below almost as soon as it came in contact with water vapor, oxygen, and nitrogen gas. The false-color image was made by an automatic sorting camera aboard the mining ship *Brancusi*.

Preliminary tests of the organism have found no evidence of toxicity. Nor is it in any way related to Earth plants.

5.3mm

While scientists were determining whether the Prato Plant is friend or foe, six mining groups in the Orion Sector have reported finding them on asteroids in ever increasing numbers.

Says discoverer Prato: "It's possible we've found our first space weed. But it's hard to dismantle an asteroid when it turns out to be somebody's home, even if it's only home to a weed."

A Living Time Capsule...
Waiting for Water.

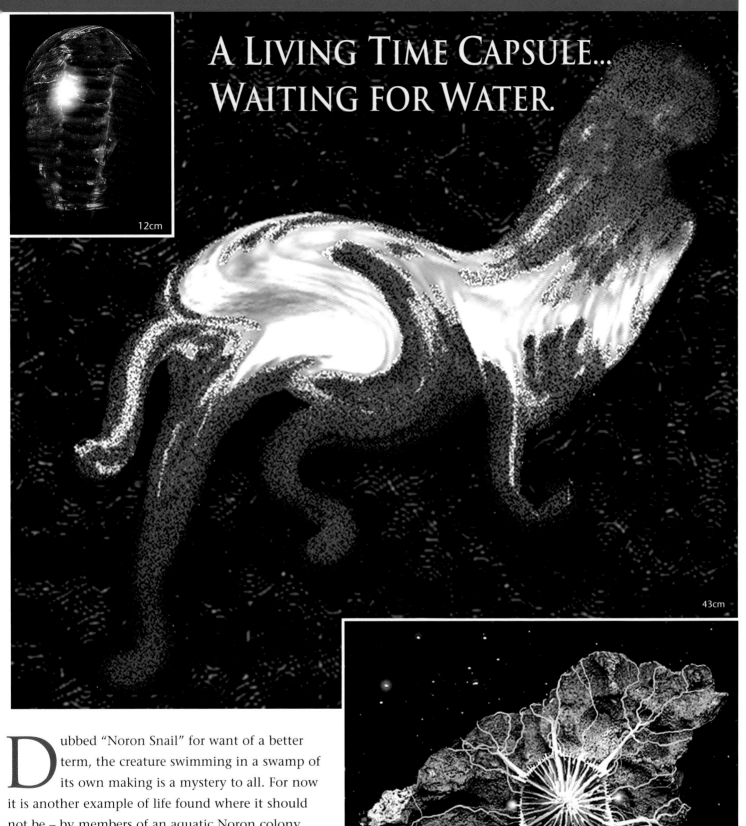

12cm

43cm

2.9km

Dubbed "Noron Snail" for want of a better term, the creature swimming in a swamp of its own making is a mystery to all. For now it is another example of life found where it should not be – by members of an aquatic Noron colony *(right)* mining a water pocket on an asteroid in a planetary debris field near Antares 77J1. The shape of the egg case *(inset top left)* alarmed Noron scientists, who isolated the specimen and brought it to the attention of *Galactic Geographic* members in the area. While under examination it hatched and, when given water, began organizing a protective water-filled bubble where it continues to thrive.

Among the strangest objects found in space are the "Wormiform Objects" – translucent mottled green chips of methane/water ice that, when heated, crack apart and grow. It is assumed that they represent a kind of unknown lifeform, but they exhibit no signs of normal mitosis or cellular division. Scientists are so far at a loss to explain the bizarre behavior represented here. At right is a typical chunk of the Wormiform Ice. Several pieces have turned up in the Piscian region of Solar Space. The image below shows the swirling transformation that occurred when the chip of green ice was heated to the melting point of water. The object broke into several smaller chips which then grew features resembling roots. The object was refrozen and taken to the Myhr Zoological Gardens for examination and further study.

LIVING ICE?

18.6cm

"WORMIFORM OBJECTS" A RIDDLE FOR SCIENTISTS

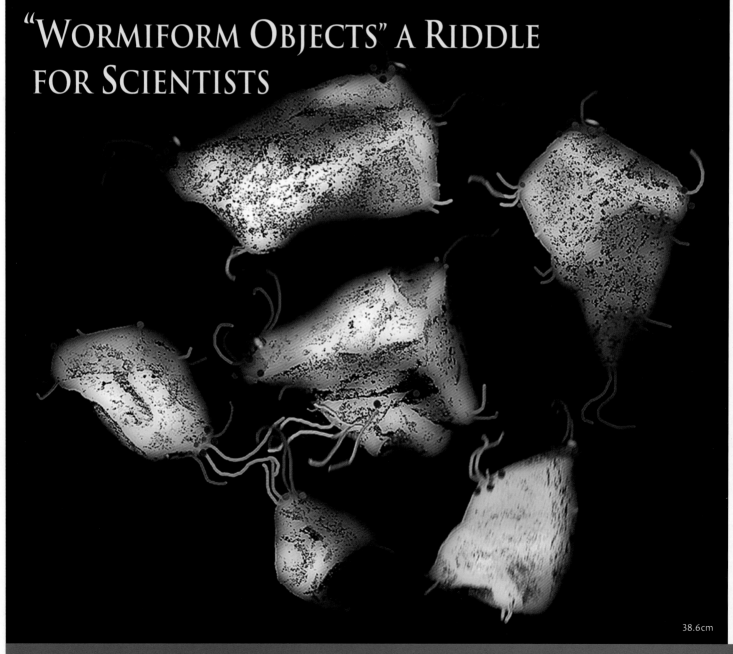

38.6cm

Dangerous Find May Not be Contained

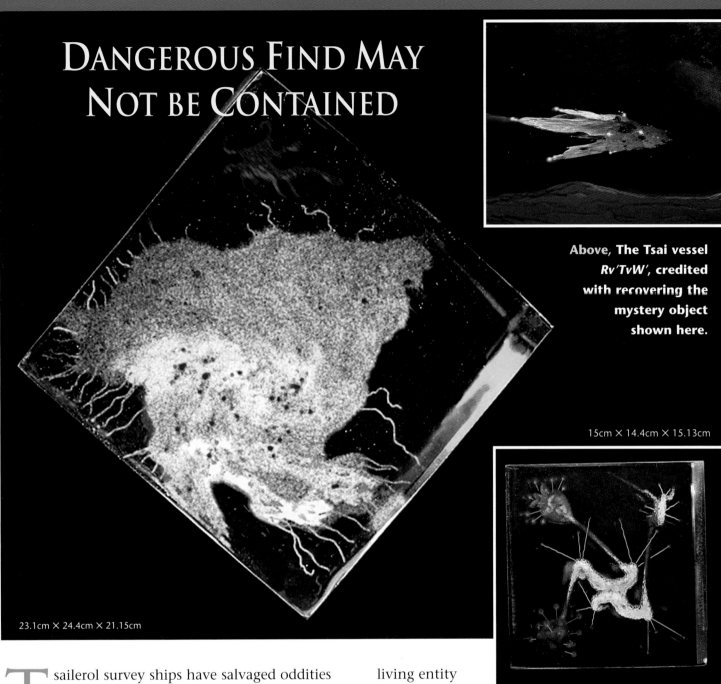

23.1cm × 24.4cm × 21.15cm

Above, The Tsai vessel *Rv'TvW'*, credited with recovering the mystery object shown here.

15cm × 14.4cm × 15.13cm

Tsailerol survey ships have salvaged oddities of many kinds. Some have been brought to the attention of resident Human colonists, hoping our knowledge might help explain them. The Tsailerol cruiser *Rv'TvW' (top right)* is a typical Tsai vessel, hewn from an asteroid. Its crew is credited with recovering the specimen shown above. Following salvage protocol, they carefully quarantined the specimen in a block of extremely dense polyceramic glass. Immediately the specimen was transported to a Federation research vessel for isolation and classification.

There, while still sealed within its isolation casing, the specimen underwent a transformation which remains a mystery. Before the eyes of amazed xenobiological researchers, what appeared to be a living entity sent out tendrils, apparently to test its environment.

The monoblock was immediately sealed inside a stasis chamber where three separate shells, two at absolute zero and one of hot plasma, guarantee the specimen cannot escape.

Shown as a comparison *(below right)* is a specimen of an unknown flower-like organism found twenty years ago on an asteroid in the Tsai system and sealed in the same material. While measurably still alive, it cannot escape its confines.

Scientists are observing the still active specimen (currently growing at the rate of 1cm per week) in hopes of learning more about this new, and perhaps dangerous, form of life.

THE NOVA STONE

Above, the Nova Stone as it was found floating in space.

Below, representation showing enhanced graphics and size

6.313m

1m

No discussion of objects found in space would be complete without mention of the most famous of them all. Scientists may be forever scratching their heads over this mystery that has become the symbol of the Federation's search for sentient life. "Some think of the Nova Stone as an image of immortality," says T. Groves Taylor, president of the largest zoological environs in the universe, the Myhr Zoological Gardens. "We may never know what it is."

Scientists retrieved the six-meter column in an area of space near the remnants of the Crab Nebula supernova. It was detected during a routine survey by the FTL starship *Houston*.

"We were looking for metals near the Crab," says Karl Kofoed, chief cartographer aboard the ship, "but we never expected to find thirty tons of nickel-iron in one place."

Most puzzling are the mysterious markings found on its surface, of artificial origin and thought to represent some kind of writing. The Nova Stone may be the remnant of a civilization destroyed in the supernova explosion.

If this is so, the stone is the only evidence of that civilization. Seven survey missions of the area have revealed nothing.

We are left to speculate as to the significance of the relic. How did it survive? Was it an important work of art or literature to those who made it? Was it a last desperate message from a doomed world?

The stone's original length is unknown because both ends are broken in a similar fashion.

The Nova Stone is not made of stone. It is 94% nickel-iron. How it survived the supernova, when we were unable to find even a fragment of a planet, is perhaps the greatest mystery of all. This relic of a lost civilization will reside permanently as a centerpiece at the Myhr Gardens. ◆

KARL KOFOED IS CHIEF CARTOGRAPHER WITH THE *GALACTIC GEOGRAPHIC* ABOARD THE FEDERATION STARSHIP *HOUSTON*.

Policing Paka

Why the Federation has broken the Colonial Imperative on Theta Retaii

A GALACTIC GEOGRAPHIC SPECIAL REPORT

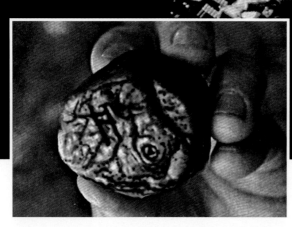

REFINED
PAKA

The oddly marked lump of material (*above*) and the red amber crystals (*right*) are refined Paka, a mild stimulant used ceremonially by the inhabitants of Theta Retaii. But its use by Human colonists traveling interstellar trade lanes has created the greatest medical and political problem to confront the Federation in its 200-year history.

PAKA CRYSTALS

PAKIS MICROBE 200X

Questions from all over the known galaxy have flooded Planis Com, the nerve center of the Federation colonies. Why has a G-Pulse star cruiser used destructive power on the surface of Theta Retaii? Why have Earth ships been forbidden to trade with this world when two colonies depend on it for their food supply? Why has the the Federation violated its own Colonial Imperative, the almost sacred resolve that forbids intervention in the affairs of our non-Human allies?

Until now these sometimes urgent inquiries have been ignored by Federation officials, a fact that troubles the Tsailerol and Noron peoples, who have demonstrated steadfast compliance with the Federation's "open-door" Human/alien policy.

To answer these questions the *Geographic* staff was invited to join Project Paka, a small task force assigned to the *Palomar*, the largest starship of the fleet, on its controversial mission to Theta Retaii.

At left is the command center of the *Palomar*, where the command staff watches a screen displaying the surface of the planet. Red areas indicate vast deposits of Paka-dust, the chalky residue of a prehistoric ocean that once covered much of Theta Retaii. The deposits contain high concentrations of crystals formed inside the skeletons of tiny microbes like the one pictured above. These crystals are the main ingredient in Paka, the substance which presents the greatest threat to the colonies since the Kierkimos Sporing of 2986.

Theta Retaii has become a primary food producer for the Federation Human colonies. In the last decade the Retaii have increased harvesting of their ocean to encourage trade with Humans. With their introduction to Federation technology came a higher standard of living and a tenfold increase in their ability to farm their oceans.

(continued)

Below, left: a crewman on board the *Palomar* monitors movements of surface researchers like Cmdr. Robert Pagh (seen below holding seabed samples gathered for testing). After analysis of his and others' findings, Project Paka was immediately implemented.

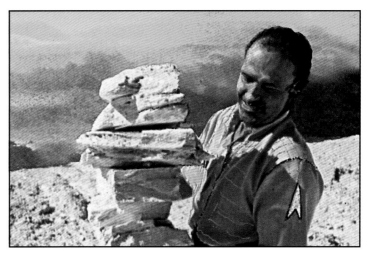

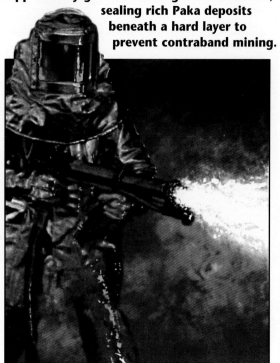

Left: Smoke from the firestorm is visible from space. Below, left and right: Drone sprayers supported by ground crews ignite the surface, sealing rich Paka deposits beneath a hard layer to prevent contraband mining.

As a result many Humans have sampled "frip," the delicately flavored marine animal that abounds on Retaii.

Retaii so closely resembles Earth that colonial traders often forget where they are. Even the physiology of its inhabitants resembles that of Earth's mammals, although their appearance, typified by the Retaii trader seen on page 113, is quite different.

Today over seven thousand Humans visit Retaii ports each year and many report difficulty because the Retaii are distrustful of outsiders. Despite their insular attitudes, simple material need has fostered an increasing camaraderie with Humans, resulting in a relaxation of Federation protocol.

The Federation takes responsibility for protection and security of its colonists but mandates that all its members practice the Colonial Imperative (CI) or "zero intervention policy" when encountering alien ecologies or cultures. Generally other lifeforms are so completely different from Humans that mutual isolation is the rule. Occasionally, however, policing of the CI has been required. Such is the case on Theta Retaii, where the Federation's worst nightmare has been realized because of the drug known as Paka.

Trade on Retaii rarely flourishes more spectacularly than on the "days of the single sun," four days of festivities in celebration of the merging of Retaii's suns in the skies. The annual celestial event has a stimulating effect on Retaii's natives. During the festival they celebrate continually, using Paka to help them endure because the event affords them little rest.

To the Retaii, Paka is a mild stimulant. But when used by Humans the drug stimulates the dream center of the brain while depressing the rest of it, inducing a state of perfect sleep. The effects are instantaneous, and users report that the drug allows them a full night's sleep in just two hours. As a result, Paka has become popular among Human traders, who often work long hours with short rest periods. Since this effect on Humans is short-lived and without any apparent negative reactions, the under-the-table use of Paka has swept through the Federation colonies in recent years.

The Federation has studied the drug's effect on Humans and found, to their alarm, that after only two doses a user develops a dependency so strong that he will suffer brain death without its continued use. And the only known cure is the dreaded cellular purge (see pictures at the top of page 113), a radical treatment that is less than 50% effective. The arduous and costly procedure requires painful hours of stepped-up cellular regeneration which ages the patient ten or more years. Perhaps more alarming is the most recent Federation estimate of 10,000 addicts. And the number grows exponentially as Paka finds its way to the more distant Human colonies.

Two weeks prior to this writing a Federation taskforce met with Retaii representatives to discuss the

Right: Refined Paka burns explosively after a "bromo-bath." Below: Caught by a remote camera, ground crew are trapped in a firestorm. Behind the wall of flame the lights of three rescue ships are visible. Sadly, they arrived too late to save the crew.

problem. The Federation acknowledged that the only path open to them was the banning of Paka use throughout the colonies and beginning the costly and arduous task of rehabilitating all known Human users. But the Federation representatives also felt that further steps would be necessary to stem the black market flow of Paka and eliminate the source. Not surprisingly, considering their love of trade, the Retaii immediately approved a plan to destroy all but a small portion of their Paka fields.

The taskforce at once secured a portion of the Paka fields, then charted their unprecedented next move, the systematic destruction of a million square kilometers of ancient sea bed with fire. The Paka deposits are located in dry barren deserts, so their destruction, while controversial, promised minimal impact on the planet's ecology.

We learned that Paka burns explosively in Retaii's atmosphere when sprayed with heated brominated water. Once the fire is ignited, only occasional spraying is required to keep deposits burning. The line of fire spreads through the soil, occasionally bursting out in small fierce firestorms. What remains after the conflagration is a thick silicate crust which entombs deeper deposits of Paka.

The actual torching of the fields progressed slowly at first because scientists warned of flare-ups that could imperil ground personnel. But, after initial stages of the operation passed without incident and over 10,000 square kilometers or one percent of the known fields had been razed without incident, impatient ground forces speeded up their work. Soon after, disaster struck as scientists had predicted. Despite careful testing and planning, an unusually rich Paka field erupted like a volcano, killing seven taskforce members and four Retaii advisors. The resulting firestorm ignited deeper deposits and grew out of control until it covered a thousand square kilometers. Before it was doused by rain, a cloud of smoke grew so large as to encircle the planet *(see sequence at the top of page 110).*

Below: A Federation outpost monitors space traffic in and out of Theta Retaii from the planet's south pole.

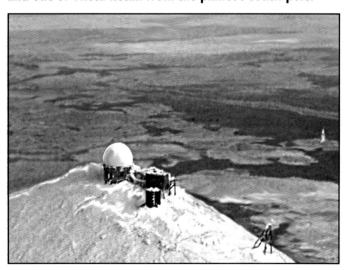

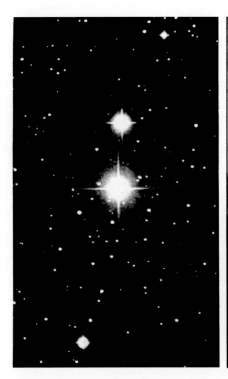

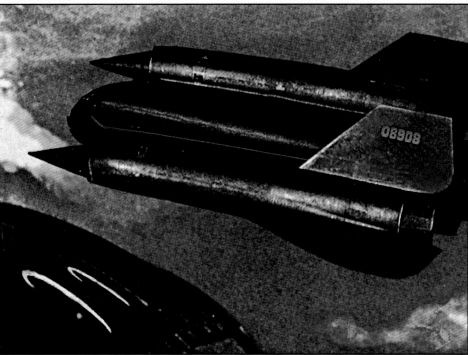

Above: The double stars Theta Retaii A and B, site of the second largest trade port in the known galaxy and the only source of Paka. Above right: A survey drone leaves the hold of the starship *Palomar* to map Retaii's surface Paka deposits.

Below and right: An image taken by a survey ship shows both the Paka fields (reddish soil) and a village where Paka contraband is traded.

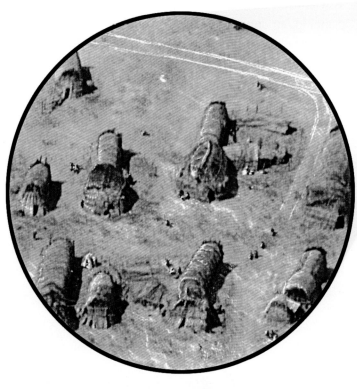

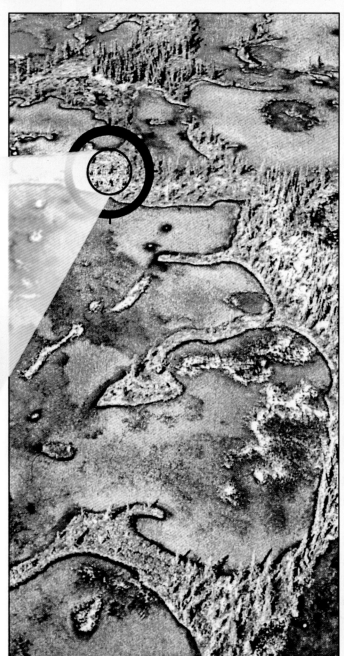

A magnified detail of the reconnaissance picture reveals a typical Retaii desert village with hut-like dwellings, inhabitants, and stockpiles of Paka awaiting shipment. Stemming the flow of Paka to Human colonies presents a delicate problem to the Federation, which depends on Retaii resources to maintain those colonies.

CENSORED IMAGE
Federation of Allied Worlds
CIVIL PROTECTION
CODE 02-19-2000

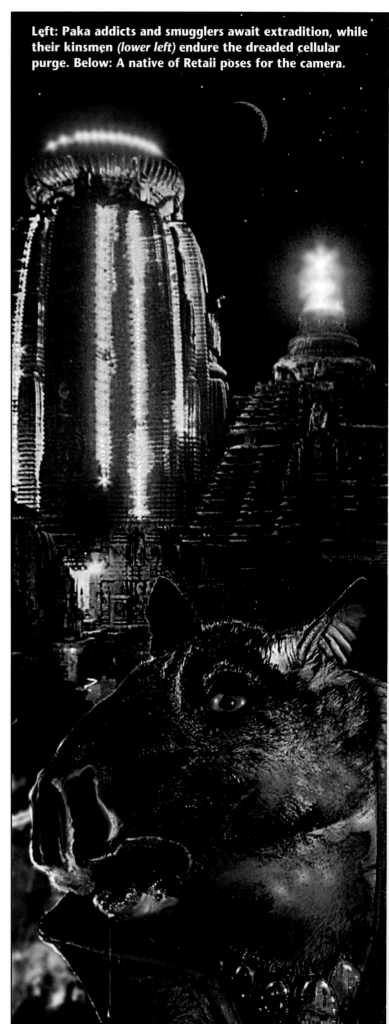

Left: Paka addicts and smugglers await extradition, while their kinsmen *(lower left)* endure the dreaded cellular purge. Below: A native of Retaii poses for the camera.

Fortunately the ecological effects of the firestorm proved to have a minimal lasting impact. And the Retaii welcomed a return to normalcy and increased trade. But for the Federation the burning of the Paka fields was only the first extreme step on a very challenging road.

Today, throughout the Human colonies, Paka addicts are being sought before the interruption of their supply causes brain death. It is estimated that over six hundred people have already succumbed to either Paka poisoning or its dreaded cure. And on Planis, the centermost of Human colonial worlds, cellular-purge module production has been increased.

The pictures presented on these pages are merely glimpses of the Paka story. Some of them, like the firestorm that took half the personnel of Division 6, are disturbing to see. But perhaps more troubling from a Federation viewpoint is the picture of an isolated FCI monitoring outpost on Retaii's southern pole. It stands as a mute reminder of the folly that is complacence. What began as a cure for space fatigue ended in an unprecedented medical problem and a scar on the Federation's integrity.

Critics of the Federation can now charge that Operation Paka has also tossed two hundred years of colonial resolve and sacrifice into the fires of Retaii.

But a broader view asserts that change is in the nature of things and adaptation to change is in the nature of life. The Federation will be more vigilant of its duty, while the Retaii claim only one hope, that controversy will increase trade.

Article by *Geographic* Reporter James Wilson ✦

Alien Drugs

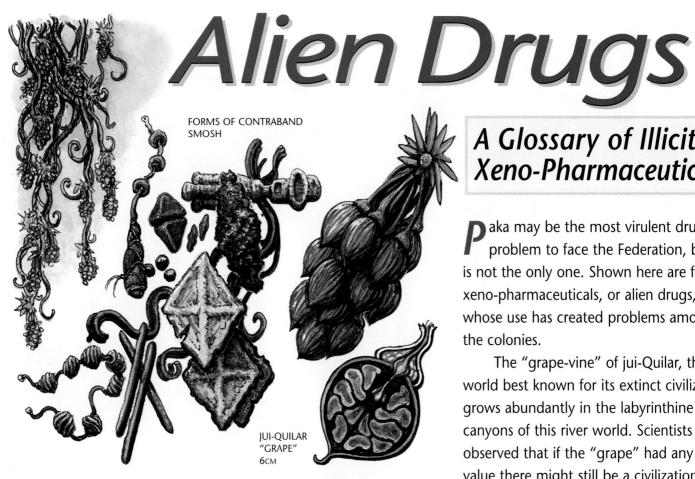

FORMS OF CONTRABAND
SMOSH

JUI-QUILAR
"GRAPE"
6CM

Grape-Vine of jui-Quilar

Reefer-Plant of Mizar II

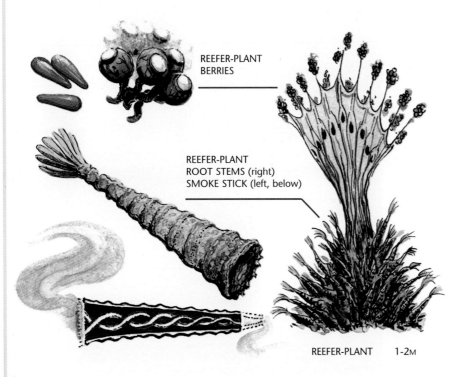

REEFER-PLANT
BERRIES

REEFER-PLANT
ROOT STEMS (right)
SMOKE STICK (left, below)

REEFER-PLANT 1-2M

Paka may be the most virulent drug problem to face the Federation, but it is not the only one. Shown here are four xeno-pharmaceuticals, or alien drugs, whose use has created problems among the colonies.

The "grape-vine" of jui-Quilar, the world best known for its extinct civilization, grows abundantly in the labyrinthine canyons of this river world. Scientists have observed that if the "grape" had any food value there might still be a civilization on jui-Quilar. The ancient society passed into oblivion when its rivers dried up, cutting off their means of transportation and consequently their food supply.

The "grape" in its refined form contains a powerful hallucinogen called smosh that resembles a black putty, moldable into many forms and shipped as contraband to other worlds, particularly Cassandra, whose attractions and casinos are popular among vacationers. Its wide use at the recreational colony has tested the forbearance of the Federation, which exercises only trade authority over its colonies.

The reefer-plant of Mizar II is similar to Earth's marijuana but more potent. Its berries are refined into pill form, but the most popular product of the plant is its root spike, which is dried and smoked like tobacco. Because it doesn't cause addiction, the reefer-plant is considered the least harmful to Humans of the drugs represented on these pages.

Drug use and abuse are as old as Human history, so the discovery of illicit drugs on other worlds is as inevitable as their use. Space colonization has added new types of drugs to an already formidable list. Newest and most unusual of these are the aromatics of Kierkimos-Toxis. There, five distinct types of creatures carry a toxic scent to ward off attackers. The scent has an unusual effect on Humans, inducing what is called an "out-of-body" experience. Little research has been done on the substance, so its effects on Humans are not yet understood.

Planis colony is a water world whose fish provide food for Human colonists. Two species, the naris and the drismar, are poisonous. The drismar possesses a spine containing a toxin that discourages other fish from feeding upon it. When processed, the poisonous substance becomes the potent drug driss, which is used as a pain killer. Addicts use a needle dipped in the sanguine liquid to medicate themselves.

The naris is a predator of the drismar because it has the same poison in its system. The naris keeps the drismar population in check and so is protected by Federation law. Still, many are taken each year, threatening the vital ecological balance of Planis' oceans.

Misuse of drugs is, of course, discouraged by the Federation. But we have learned many times in the past that personal habits cannot be legislated or regulated. Education and common sense are now, as always, the most effective preventer of drug abuse. ◆

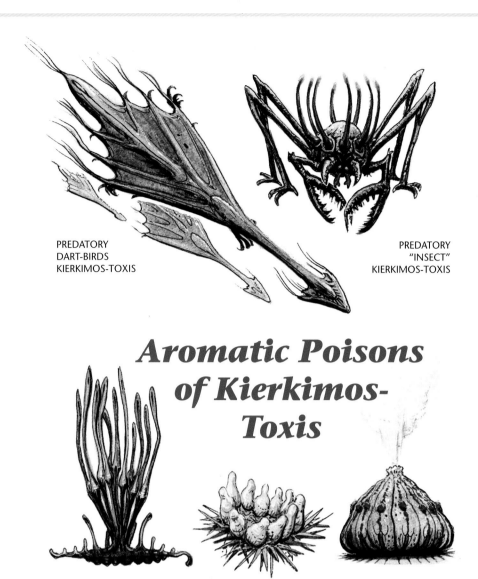

PREDATORY DART-BIRDS KIERKIMOS-TOXIS

PREDATORY "INSECT" KIERKIMOS-TOXIS

Aromatic Poisons of Kierkimos-Toxis

THREE TYPES OF FOLIS X-FUNGI – KIERKIMOS-TOXIS

DRISS MEDICINAL APPARATUS

Drismar

DRISMAR 22CM

Naris

NARIS TABS

NARIS 322CM

MUSIC OF OTHER WORLDS

UNKNOWN INSTRUMENT

SIDE VIEW

TOP VIEW

9.993cm

Perhaps a valve to con[trol] the flow of air or water, [this] object is made of reson[ant] materials and stone.

Many languages exist, a philosopher observed. Music is just one of them. Language or art? Whatever we may think of it, music has always been difficult for Humans to define. Now, as mankind's influence expands to the stars and we become part of a galaxy populated by other races and civilizations, we find the task even more difficult. To Humans music is a form of sonic expression, usually not considered a language. But by others it can be found in forms as varied and unusual as the instruments that create it.

IMAGES COURTESY GGS ARCHIVE NWTC NuYORK EARTH

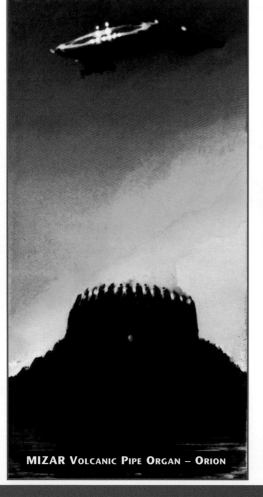

MIZAR VOLCANIC PIPE ORGAN – ORION

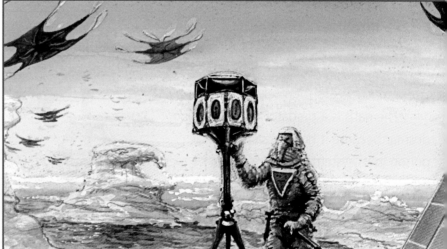

Speakers playing music called "Disco" repel unwanted pests on icy colony.

"Samba bugs," living under the Europan ice pack, use high-frequency music to locate microscopic pr[ey]

INTRODUCTION

*M*usic, in all its diverse forms, "is where you find it," said the jazz great Charlie "Bird" Parker (1920 – 1955). Those words were true when he said them a thousand years ago, and they ring true today as faster-than-light Federation ships probe deeper into the universe around us.

In this series we look at the music of Jupiter's Reef, where the hummer's song ignites luminescent fires within its prey to make them visible in the endless darkness *(right)*, and Mizar *(opposite, bottom left)*, where a volcanic pipe organ resonates music loud enough to be heard all over the planet.

We'll examine these and other diverse forms of musical instruments, some of them known and others unknown *(top left)*. And we'll see that music has diverse purposes, as on Epsilon 4 *(opposite)*, where colonists found that ancient music called Disco gave them freedom from a flying pest.

In "Water Music of the Noron" we'll see how the Noron use music to communicate and to measure time.

And in "Music of the Spheres" we will see that music knows no scale, be it microscopic, like the Samba Bugs under the permanent ice on Europa *(opposite)*, or titanic, like the melodic vibrations of black holes as they gobble up different kinds of stars. We observe that music in all its diversity is indeed, as that jazz great of old said, "where you find it."

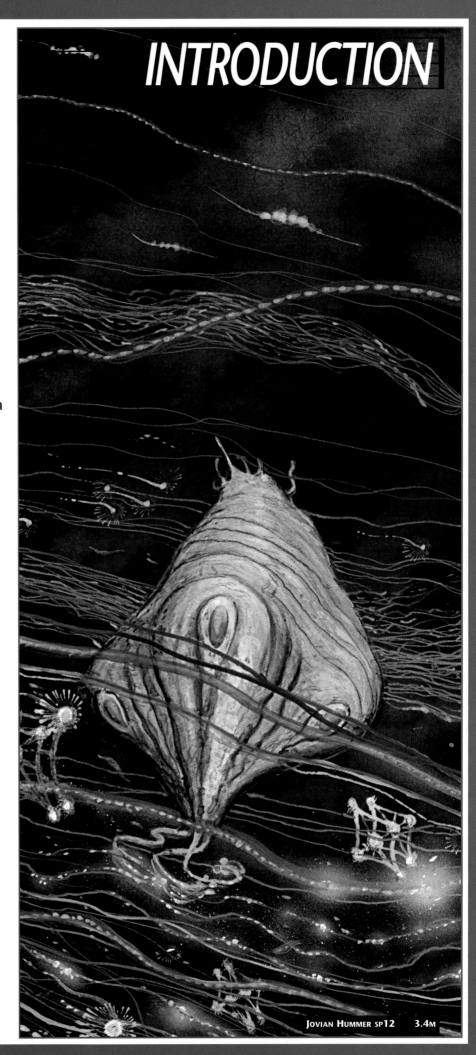

JOVIAN HUMMER SP12 3.4M

117

SONGS FROM THE GREAT RED SPOT

Before the year 2000 few would have expected to find music – or life, for that matter – on the planet Jupiter. Unlike Earth, the "King of Planets" is an immense seething ball of hydrogen, helium, and other elements, called a gas giant. But deep under the water-rich clouds of its Great Red Spot is a zone of life. There, over time, the building blocks of life have collected and evolved, forming a floating reef larger than Earth and containing thousands of diverse lifeforms, even some that sing.

For centuries astronomers wondered why the size and structure of Jupiter's Great Red Spot didn't change over time, as did all other Jovian storms. The reason was a density difference, and the material that accounted for it became known as "Jupiter's Reef."

A manned Null-G probe, part of an ongoing research mission, is released from its tender to begin a descent into the Great Red Spot. Its team of a half-dozen researchers will conduct new studies on the origins of life.

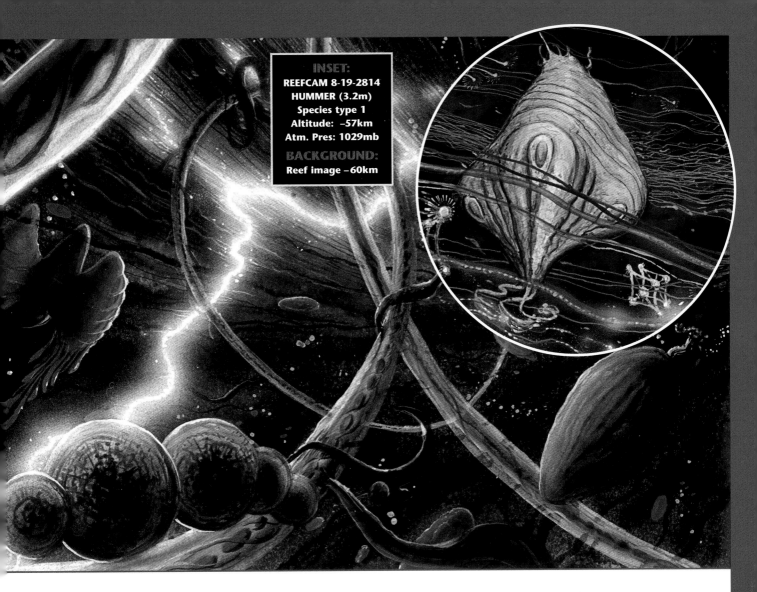

Two species of Jovian hummer are shown on this page, grazing on floating creatures that glow when the hummers sing. Swimming in the warm water-rich gases, the hummer produces a low droning sound as it floats amid wispy shoals of air coral, whose mass comprises 90% of the total reef and provides a home for countless other creatures.

The song idea came when explorers, called reef-divers, noticed that the creature's sound stimulated tiny creatures to glow and others of its kind to hum along. Each one adds to the chorus, and a glow spreads out through the reef. The sound and light show builds, like a musical crescendo, until a bolt of lightning shatters the air. Then silence and darkness return to the reef. But only for a short while. Soon, one of the hummers regains the courage and the appetite to begin singing for its supper, and the cycle begins again.

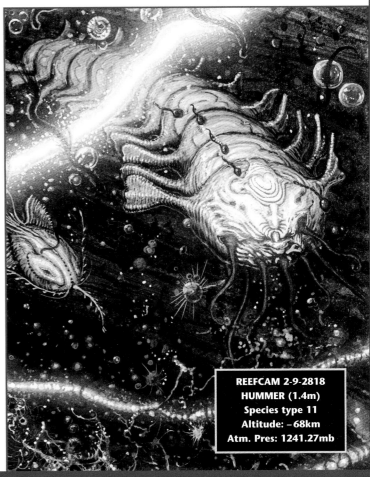

Water Music of the Noron

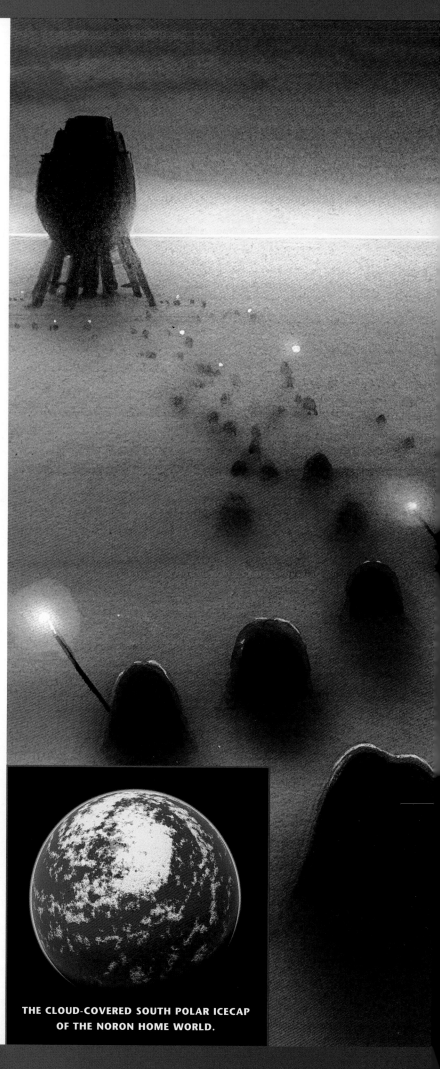

Music has many forms, but it seems that only technological races produce it as a separate and distinct language. The Noron are no exception.

In the shallow salton seas of the Noron planet, sixth from their sun Iridani Prime, music serves as a calendar. Using a complex sonic language like Earth's cetacean populations, Noron communities produce a kind of music to keep time.

On the sunrise of their equinox, reefs all over the globe celebrate the Iridani version of the New Year. As shown in the picture on this page, the Noron raise their soft bodies from the water to witness sunrise. In the background is a relic launch facility – a memorial to early space efforts.

At the sunrise ceremony shown here, senior members of each Noron clan carry torches burning with chemical energy called "aquafire" – magnesium condensate that burns underwater. Its invention, eons ago, saved the Noron from extinction when a slight orbital shift of their planet brought on the first of their great ice ages.

Some see in this a historical parallel to Human evolution. On Epsilon Iridani, as on Earth, adversity brought about invention and, ultimately, technology and space travel. It is remarkable that this happened to an aquatic species. Unlike mankind, Noron survival had always been assured by the abundant life in their seas. For them, hunting and tool making were never a necessity until an ice age wiped out half their population. To combat the cold, the Noron were forced to create an artificial heat source.

THE CLOUD-COVERED SOUTH POLAR ICECAP OF THE NORON HOME WORLD.

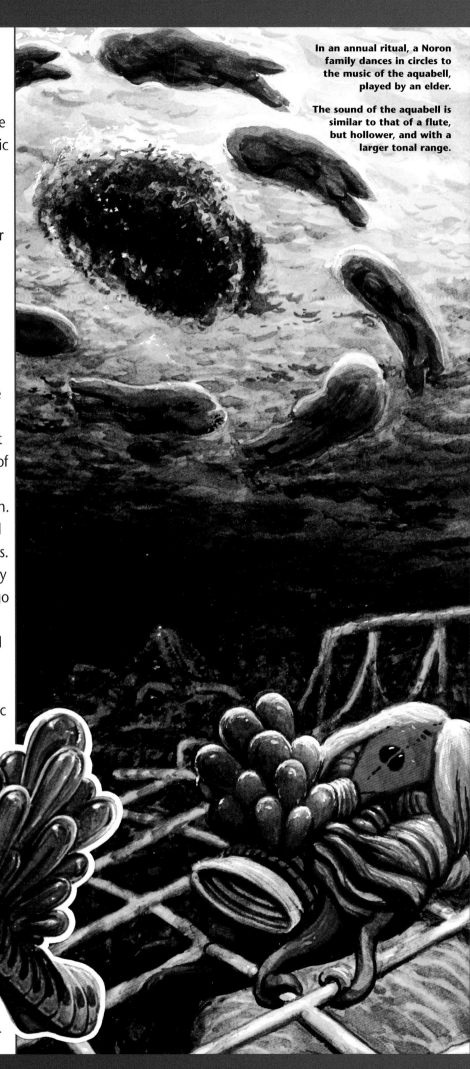

Inevitably, the Noron turned to tool making, and creativity became their guiding spirit. Even the Noron language was affected. As population increased, the sounds of their commerce became chaotic and unbearable. The solution was music.

Harmony, meter and tonal structure became the rule for all communications. Instruments were invented to add greater sonic range and more complexity to their vocalizations. The oldest of these instruments is called the aquabell by Human colonists. Activated by water moving through different-sized silicon cells, it is used ceremonially and to communicate daily messages everywhere on the planet.

At right, an elder plays an aquabell at an annual ceremony honoring the birth of his children. Above him, clan members swim around an egg mass about to hatch. The music communicates the event to all and has a soothing effect on the hatchlings.

Most know that the Noron's discovery of a space probe from Earth a century ago led to our first contact with them. Few, however, are aware that music contained on a recording placed aboard the probe induced the Noron to make contact. It impressed them that Humans value music enough to put it aboard a space probe bound for nowhere.

Though we have music in common, our differences are many. Few Humans can relate to an aquatic existence, and the Noron have difficulty with the concept of living on land. At a recent Federation conference, a Noron representative commented, "Humans sound better than they look."

In an annual ritual, a Noron family dances in circles to the music of the aquabell, played by an elder.

The sound of the aquabell is similar to that of a flute, but hollower, and with a larger tonal range.

MUSICAL INSTRUMENTS

Fretless fingerboards evidence the tonal quality of the TSAI-TAR.

Its strings are touched but not depressed by the Tsai musician *(far left)* as he plays the instrument during a festival.

Pseudopods, with their highly flexible musculature, allow the Tsai musician to deftly slide up and down two tonal scales provided by twenty strings of tensilized carbon. A third pseudopod picks both sets of strings at the same time.

*B*efore a few years ago, few Humans would have suspected that a musical instrument could be powered by will alone. But today the VoxUniversalis *(pictured below)*, now familiar to most Humans, is just such an instrument. Invented by S.P. Somtow in 2990, the Vox is the first device to amplify thoughts and transmit them to other minds. The Vox does not create sound waves but articulates music to the listener, and does it so perfectly that, when Tsailerol "heard" it for the first time, they were convinced the sound was supernatural.

In the picture above, a Tsailerol musician plays an instrument made by Human colonists. Designed to be played only by a Tsai, it was created to demonstrate

(Below) Found recently by a Geographic team, this relic from the toxic planet Green resembles a reed flute.

14.2cm

10.51cm

(Right) An ancient fragment (over 2 million years old) found on the far side of Earth's moon. Although it is only part of the original object, analysis has determined that it is made from a resonating wood-like material wrapped in organic matter of a different type, possibly once living tissue.

(Left) Unearthed at an archaeological site on Planis Colony, this is not a just a skull, as originally thought, but a skillfully crafted percussion instrument made from several types of Planisian sea creatures.

22.6cm

.93m

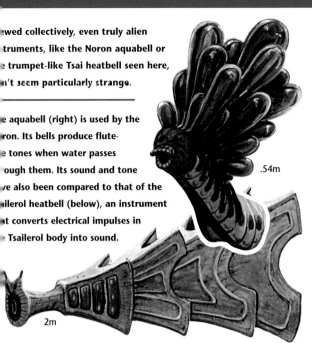

...ewed collectively, even truly alien ...struments, like the Noron aquabell or ...e trumpet-like Tsai heatbell seen here, ...n't seem particularly strange.

...e aquabell (right) is used by the ...ron. Its bells produce flute-...e tones when water passes ...ough them. Its sound and tone ...ve also been compared to that of the ...ilerol heatbell (below), an instrument ...t converts electrical impulses in ...e Tsailerol body into sound.

.54m

2m

...r spiritual kinship with them. The tsai-tar is ...sed on an ancient design (the electric guitar), ...t has crisscrossed fingerboards and strings ...signed for a three-armed player. To the Tsai ...has become a symbol of unity between our ...ltures. Its success was a surprise to the Human ...lonists. "It was intended to be a symbol that ...uld be played. It was not assumed that it *would* ... played," says musician Chris Frank, builder of ...e instrument.

At right, the stars of the Pleiades shine like ...otlights above the heads of a Tsai musician and ... "engineer," who are introducing the music of ...e tsai-tar to a Tsailerol crowd for the first time. ...e sound column, of Tsai design, serves only as ... amplifier for the event. The concert was very ...tertaining to the Tsai. But Human colonists ...scribed it as a cacophony of unconnected tones ...at changed so fast they couldn't make sense of ... "The Tsailerol have a different time frame," ...lects Frank, on hand for the unveiling of his ...trument. "Their nervous system works faster ...an ours. And they have no sense of rhythm, I ...ppose because they don't have hearts to give ...em a sense of rhythm, as Humans do."

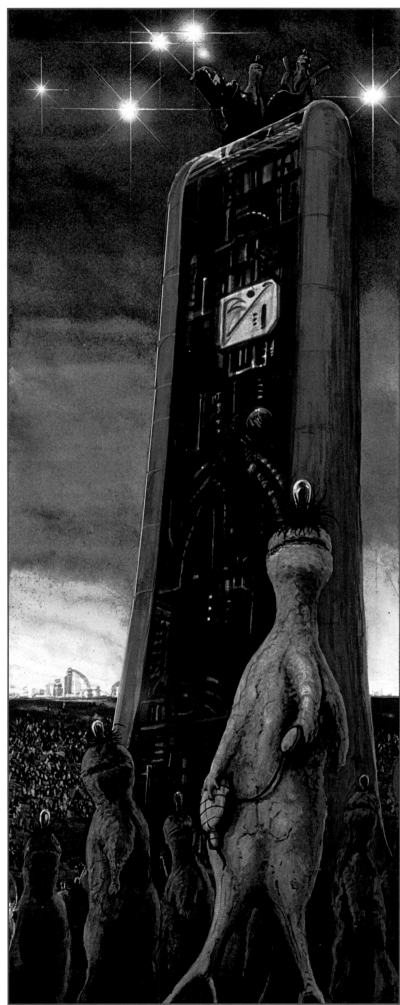

The Volcanic Music of Mizar

We have seen that music, or something like it, can be found in forms as varied and unusual as the instruments used to create it.

On Mizar, a planet in the Orion B system with an insect-like population, music is primarily a means of global communication. And it is played on a mountain-sized pipe organ powered by a volcano.

Mizar's organ wasn't discovered immediately by the colonial pioneers who first charted the mist-shrouded planet.

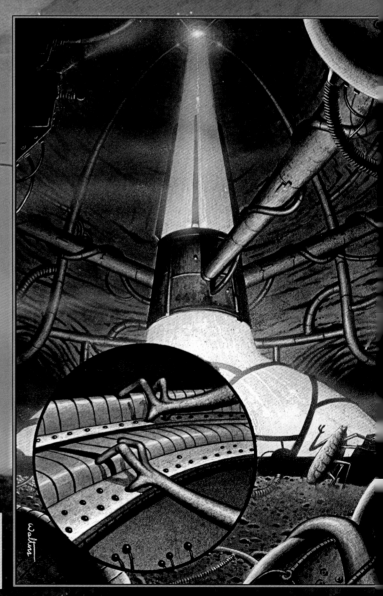

Inside the domed control center, and surrounded by a maze of pipes that drive the mountainous organ, many natives are needed to play the instrument, whose main console has a keyboard made for four-fingered musicians.

ART: ROBERT WALTERS/KARL KOF

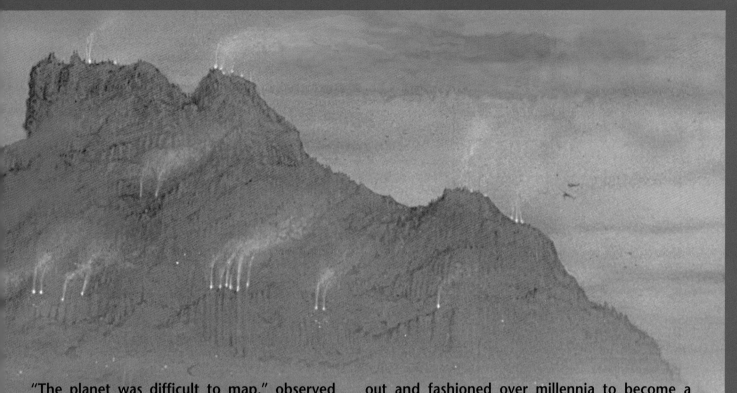

"The planet was difficult to map," observed colony commander Bruce Howze. "It wasn't until we set up our seismic gear that we heard the mountain. We located it inside a gigantic meteor crater whose circular shape makes it an excellent transducer."

On the opposite page *(inset)* we see the interior of the mountainous volcano, hollowed out and fashioned over millennia to become a means of low-frequency communication for the entire planet. The image shows the organ's console, thermal shaft, and the labyrinth of pipes that drive the organ, producing sound pressure levels of 190dB or more.

Below *(left)* is one of the denizens of Mizar undertaking a ritual watch. The apparatus the creature is setting up is thought to be some type of receiving device. He and his kin absorb the news of the day through their feet.

"We have no idea if it's music," adds Cmdr. Howze, "But it was music to our ears. Without it we never would have found them."

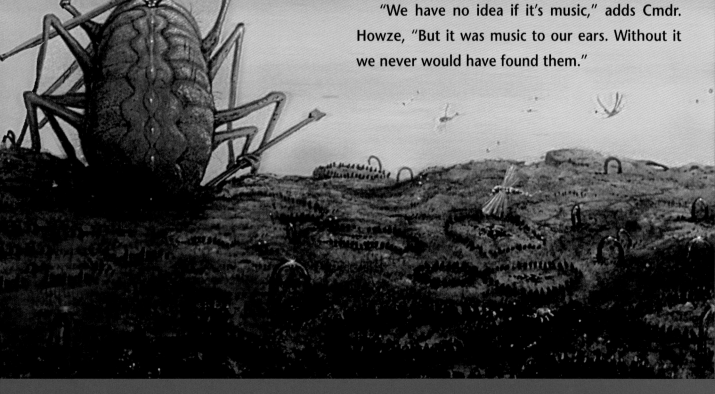

Music of the Spheres

"You are the music
while the music lasts."

T. S. Eliot – 20th-century poet

(Above)
Deep space sonde image
of the Milky Way Galaxy

(Right)
Music is found everywhere life exists

Space exploration has, in the 31st century, become commonplace. Few Humans would argue the benefits reaped from our expansion to the stars. We need look no further for the value of technological growth than the rapid recovery our civilization has made from the wars of the 2nd Millennium. By focusing outward, our place in the universe is clarified.

Music has always been regarded as an expression of the inner self, a personal form of communication like language but pertaining to emotions, rather than ideas.

But it can be argued that music is also produced by inanimate matter, and every celestial body has its own musical identity.

This is not a new idea. A thousand years ago planeta probes from Earth discovered the radio music of the planets Jupiter and Saturn. Whistles and beeps, mournfu groans, and ethereal tonal sweeps characterize the audio interpretations of these emissions.

With radio astronomy came the discovery of the radio "songs" of the stars. But, even before this, Human equated music with celestial bodies. The 20th-century suite by Holst entitled "The Planets" is a famous exampl

Today, Humans have learned that the "music of the spheres" is more than a romantic idea. The electro-magnetic spectrum carries music in many forms.

If you could walk on the surface of the Sun and had

(Left) Earth's moon, still ringing like a bell from an ancient asteroid impact

(Right) Two giant stars pull gas from each other's surfaces in a dance of mutual destruction

s able to hear ultra-low vibrations, you would hear the ringing like a bell in three harmonic tones. Listening hese, one might wonder if the Sun were a living ature humming its favorite tune.

Today scientists listen closely to the music of the estial spheres. The songs they sing tell of radiation sts, magnetic disturbances, or even the imminent losion of a star. But is this music? Perhaps what is ly in question is not if it *is* music, but rather if we *think* music. Our perception of a thing is, after all, what kes it real. One might argue that music must come n a musician, not a star. But what is a musician?

In discussing the music of the spheres we must consider all the spheres, down to the very heart of matter – the atoms themselves. The vibrations of these tiny bundles of energy guide the bonding of molecules. One might wonder: is sodium singing a love song to chlorine when it creates salt? Laughable, perhaps. But if music exists everywhere, it is certainly inside each of us, hardwired into us as surely as is the star stuff from which we are made.

If mankind is truly the crown of terrestrial creation, perhaps we should listen to music, wherever we may find it. By doing so we not only grow in consciousness and experience, but we can also learn to appreciate and improve our own songs.

◆

First published in Great Britain in 2003 by
Paper Tiger
64 Brewery Road
London N7 9NT

www.papertiger.co.uk

A member of Chrysalis Books plc

9 8 7 6 5 4 3 2 1

British Library Cataloguing-in-Publication Data:
A catalogue record for this book
is available from the British Library.

ISBN 1-84340-070-7

Designed by Karl Kofoed
Edited by Paul Barnett

Printed and bound by Craft Print Pte Ltd Singapore